001

002

Richard Wilson SLIPSTREAM

Edited by Jean Wainwright

With an introduction by Mark Davy

FUTURE\CITY

003

Published by Futurecity Ltd.

Futurecity Ltd.
57 Clerkenwell Road
London EC1M 5NG
futurecity.co.uk

Futurecity Ltd. © 2014
All works © the artist 2014
All texts © the authors 2014

ISBN 978-0-9928938-0-4

British Library Cataloguing-in-Publication Data
A catalogue record for this book is available from the British Library

Designed by Jeremy Timings
jeremytimings.com

Printed in the United Kingdom by
Taylor Brothers on FSC certified paper.

Contents

006

Part_No.01

Introduction

By Futurecity's Mark Davy

'The whole project is almost a metaphor for the history of flight:
I think I'm Orville Wright and I'm there with my quill and canvas –
yet we've ended up in the cockpit of a jumbo jet.' *Richard Wilson, 2014*

The story of the Covered Court commission for Terminal 2 : Queen's Terminal at Heathrow started early in 2010 : that was when I was introduced to the Heathrow design team by architect Jolyon Brewis, chief executive of Grimshaw Architects. Discussions were taking place about plans for the Covered Court – a large space similar in size to the Tate Turbine Hall – envisaged as a grand architectural entranceway by the architect Luis Vidal.

That first meeting involved detailed discussions of culture and placemaking and how the use of the arts – rather than a more traditional approach – might introduce the idea of a cultural gateway to London. The idea of a high-profile artwork that could symbolise the entrance to London for millions of visitors each year was presented to the Heathrow design team in 2010 – and the Covered Court commission was born.

For inspiration, the design team looked to the enduring success of Tate Modern, the former power station converted into a world-class gallery. In particular, the hugely successful Unilever Series provided ideas for a radical approach to commissioning for the Covered Court. The series has delivered exciting installations by artists using the scale and volume of the Turbine Hall, including (still memorable) interventions such as the groundbreaking *Weather Project* by Danish-Icelandic artist Olafur Eliasson in 2003 and Louise Bourgeois' steel towers *I Do, I Undo, I Redo*, which were shown in the Turbine Hall when

the gallery opened in 2000. We were also interested in the huge number of visitors that would access the new terminal, delivered by 23 Star Alliance airlines, Aer Lingus, Germanwings and Virgin Atlantic Little Red. Since it opened in May 2000, more than 40 million people have visited Tate Modern* compared to the estimated 20 million per annum expected to enter the Covered Court. Could we use the commission to attract a new audience through our cultural gateway and attract a new following for contemporary art?

Admittedly, the idea of using a monumental artwork to define 'place' is not new: Antony Gormley's *Angel of the North* (1998) has been a successful global icon for the regeneration of Gateshead in north-east England. In Chicago, Anish Kapoor's *Cloud Gate* (2006) has become the ultimate 'selfie' moment for anyone recording their visit to the Millennium Park in the United States' Windy City. However, in a century already defined by digital technology and global information networks, the public seem more interested than ever in the vision of the artist. That said, developing a large-scale artwork for an international airport is different from a commission for a public square or new park. The ambition for the artwork – to dominate the Covered Court – meant that Heathrow might receive artists' proposals that would radically alter the design of the space.

The final artist brief offered suggestions for the commission based

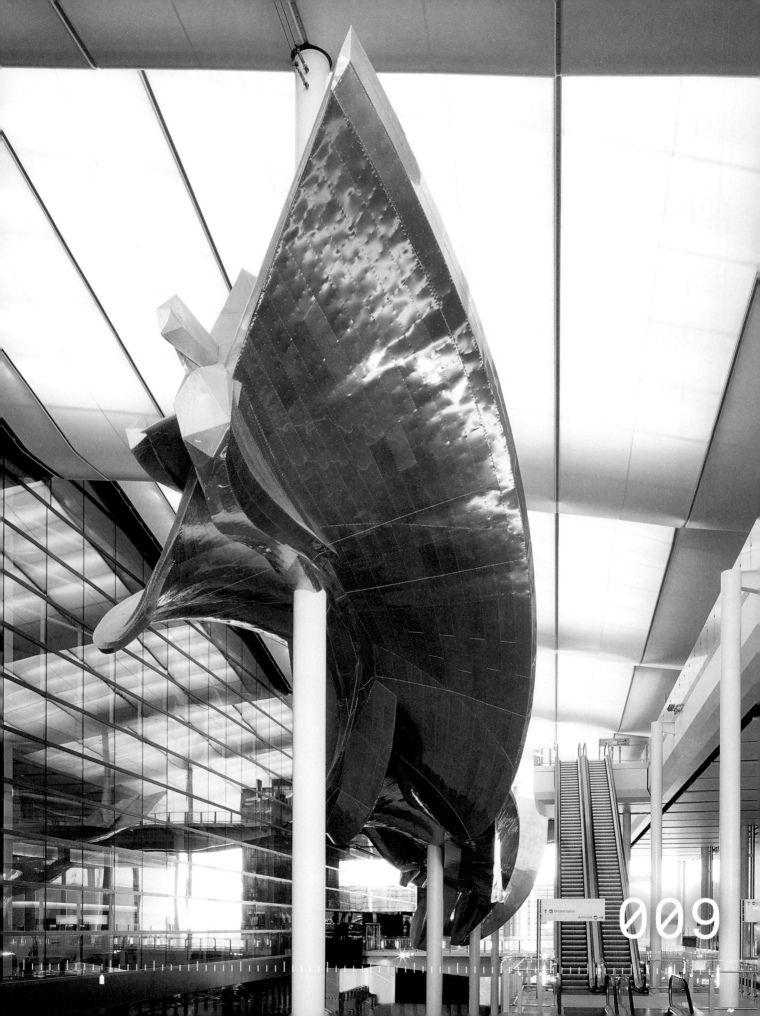

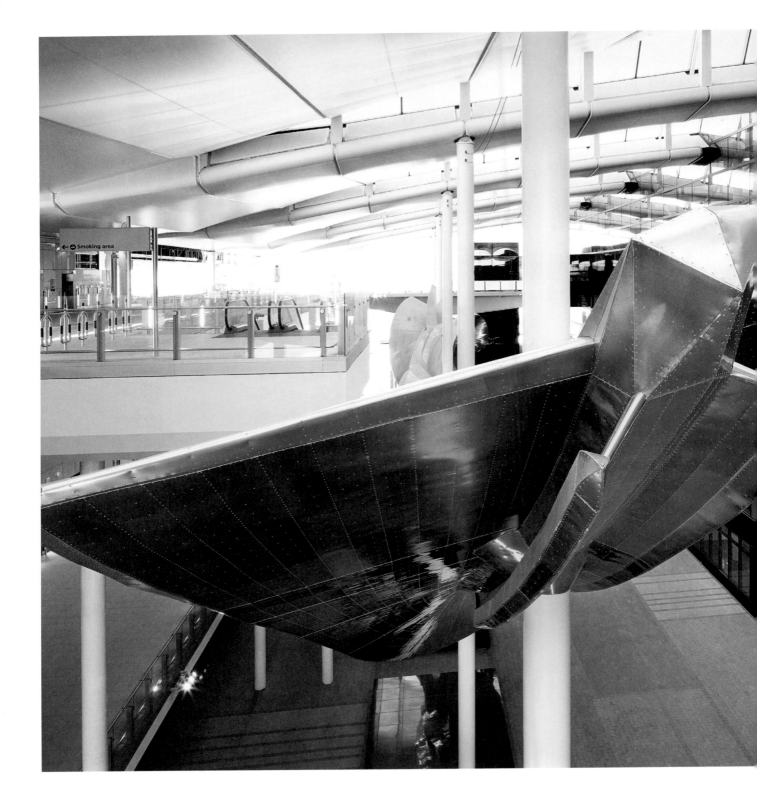

010

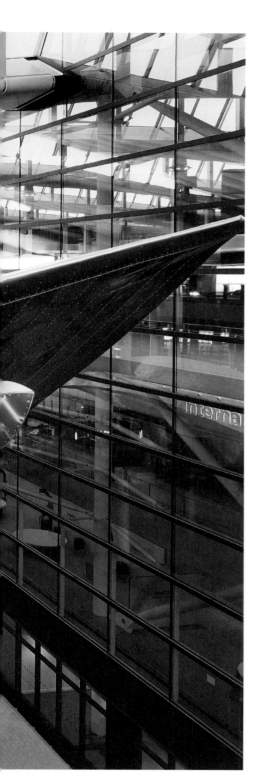

on travel, movement, communication and global links on history and heritage. However, the real challenge for five of the world's leading artists (shortlisted from Japan, the United States and the United Kingdom) was how to make full use of the unprecedented opportunity to propose a monumental artwork that could fill the void of the Covered Court and provide a world-class artwork for the new terminal building.

Richard Wilson's *Slipstream* was selected from a longlist of five public art proposals presented to the Heathrow Design Team on 8th December 2010. Wilson's team arrived late, crowding into the grey corporate meeting room and outnumbering the selection panel. They spent most of their allocated time unpacking Wilson's numerous working models, pinning up drawings and laying out construction materials on every available surface until we were transported to a version of his studio.

It was a bravura performance and there was a palpable sense of excitement and energy in the room as he expounded his proposal for a sculpture inspired by the world of aviation, combining precision engineering and specialised UK craftsmanship. Wilson's definition of 'slipstream' in this case was a sculptural 'uninterrupted stream or discharge' through the Covered Court. It would follow the imagined flight path of a Zivko Edge 540, an advanced aerobatics aircraft designed and built in Guthrie, Oklahoma, made famous by British pilot and Red Bull Air Race world champion Paul Bonhomme.

On reflection, it was interesting to note that many of the shortlisted proposals for the Covered Court commission made visible use of technology such as film, lighting and kinetics. All of these elements would reflect Heathrow's role as a major airport and transport hub where engineering, design and aesthetics come together in spectacular fashion.

However, in Richard Wilson's *Slipstream* the technology was hidden, tucked away inside a sleek, undulating form that required the help of cutting-edge methods of design, engineering and fabrication to be realised. Wilson's masterstroke was to take the constituent parts of the flying machines that have fascinated us for over a century and, through a vast alchemical experiment, fuse the physical, scientific and emotional in one endeavour. His proposal cleverly communicated our faith and trust in technology as well as the human touch required to get us to our destination.

Wilson finally started work on the Covered Court commission in spring 2011. His early proposals now showed *Slipstream* slightly shorter in length – trapped between two passenger bridges – but integrating the architecture of the terminal and slung off four of the building's structural columns.

The ambition of Wilson's proposal, the complex supply chain involved and *Slipstream*'s intricate shape and weight meant the project had to be a model of collaboration and partnership from the outset. Preparations were made to embed his proposal into the delivery programme of HETCo (a Laing O'Rourke/Ferrovial Agroman joint venture), which was leading the construction of Terminal 2.

Every part of the project required innovation and bespoke methods of fabrication, design and installation; even the delivery of the 23 huge component sections required military planning and precision. *Slipstream* was transported by low-loader from the Hull-based manufacturing plant in north-east England across six counties, smuggled into the terminal after dark across the main runway of one of the world's busiest airports. As the project progressed into 2013 it was clear that the commission was now far beyond a philanthropic gesture.

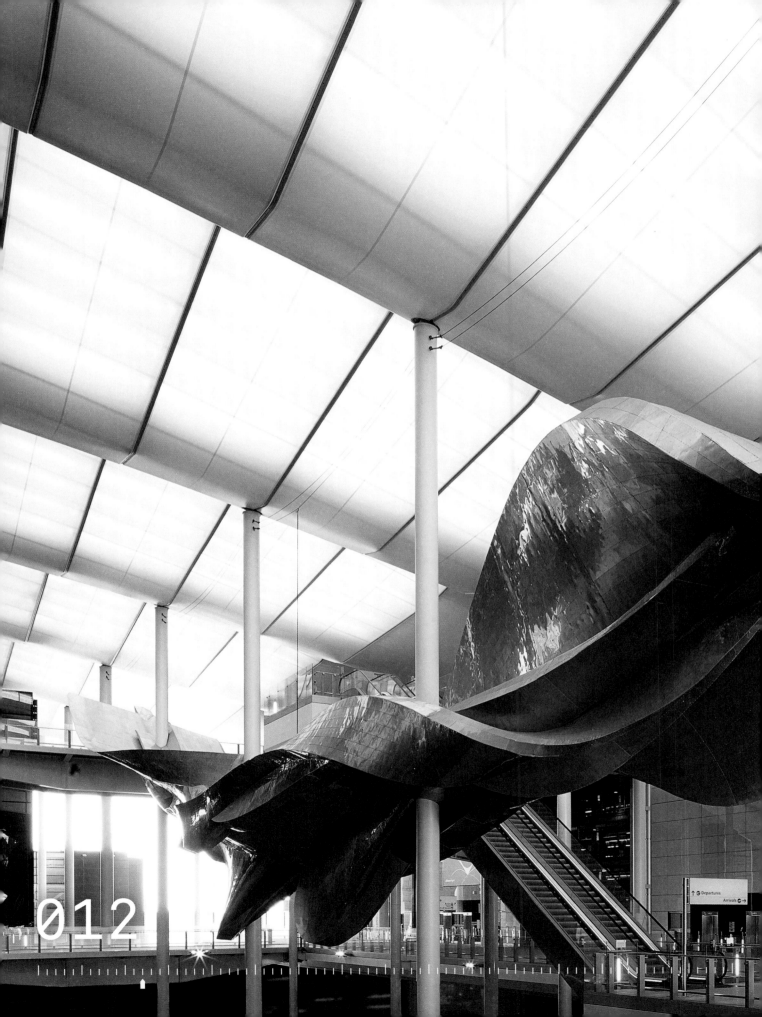

012

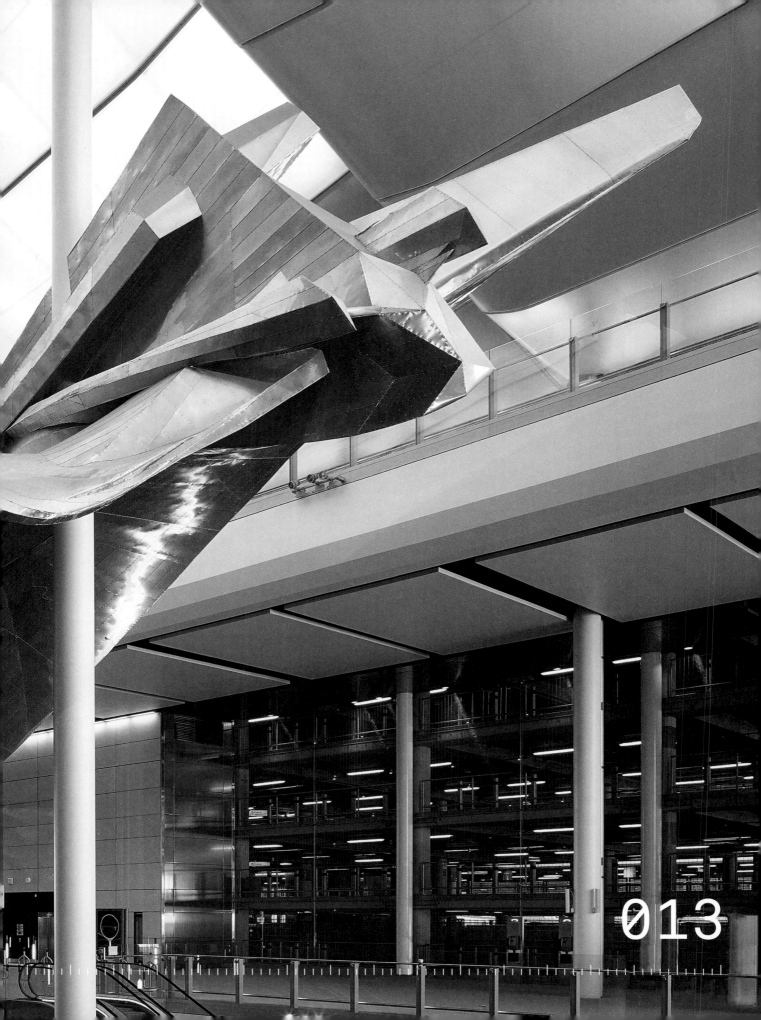

013

By late 2013 it was obvious that Wilson had been the right choice for the Covered Court commission. He had managed to find ways of bringing the inventiveness and playfulness of his large-scale temporary works to the Covered Court, communicated through dozens of drawings, photographs, collages and low-tech models of cardboard and wire. There was even an old hamster ball adapted to hold a cardboard plane, which he would roll for anyone interested in seeing the inspiration for a tumbling aircraft.

Wilson also brought his trademark hands-on approach, refusing to devolve responsibility for *Slipstream*'s construction entirely to the fabricator and engineer. Instead he encouraged a collaborative process from the outset to find solutions that were both practical and visually stimulating. His infectious curiosity about how the world works and his genuine interest in understanding the trades and professions of those around him helped to establish a team dedicated to realising his extraordinary work.

Great art can provide the catalyst to turn a place into an experience. *Slipstream* has already triggered a discussion about 'galleries without walls' and how the sculpture might change perceptions of public art. As the terminal nears completion the paraphernalia of lighting, equipment, gates and signage have begun to populate the space. Lifts and escalators have been turned on and Luis Vidal's extraordinary digital kinetic lighting is casting coloured light on the aluminium surface of the sculpture.

Exciting things are starting to happen in the Covered Court, too. Not least among them is the view of the sculpture from the escalator as it rises up 10 metres, diagonally, along the entire length of *Slipstream*, placing passengers within touching distance its body. Then there is the wonderful panoramic view of the twisting, tumbling form of the sculpture for passengers leaving the lifts at Arrivals. But it is the reflection of the sculpture in the canyon glass wall of the terminal that really surprises. The great leviathan slumbering in the deep green of the glass is 78 metres of riveted aluminium soaring through the four support columns under the undulating waves of Luis Vidal's majestic roof.

Wilson's work focuses on deceptively simple ideas that can be easily understood and experienced. With *Slipstream*, his largest permanent work in the UK to date, he has set out a distinctive narrative for Heathrow: travel is liberating, exhilarating and gravity-defying – and the closest thing to magic for those of us who don't know how to build or fly a plane.

Author and philosopher Alain de Botton was appointed as writer-in-residence for Terminal 5. He describes airports as places where big global themes come to life and says, 'If you wanted to take a Martian to a single place that best captures everything that is distinctive and particular to modern civilisation in its highs and lows, you would undoubtedly take them to the airport.' If they come, Wilson's *Slipstream* will be the first thing they see.

Mark Davy Director of Futurecity and curator of the Covered Court Commission

*Source: tate.org.uk/about/ who-we-are/history-of-tate

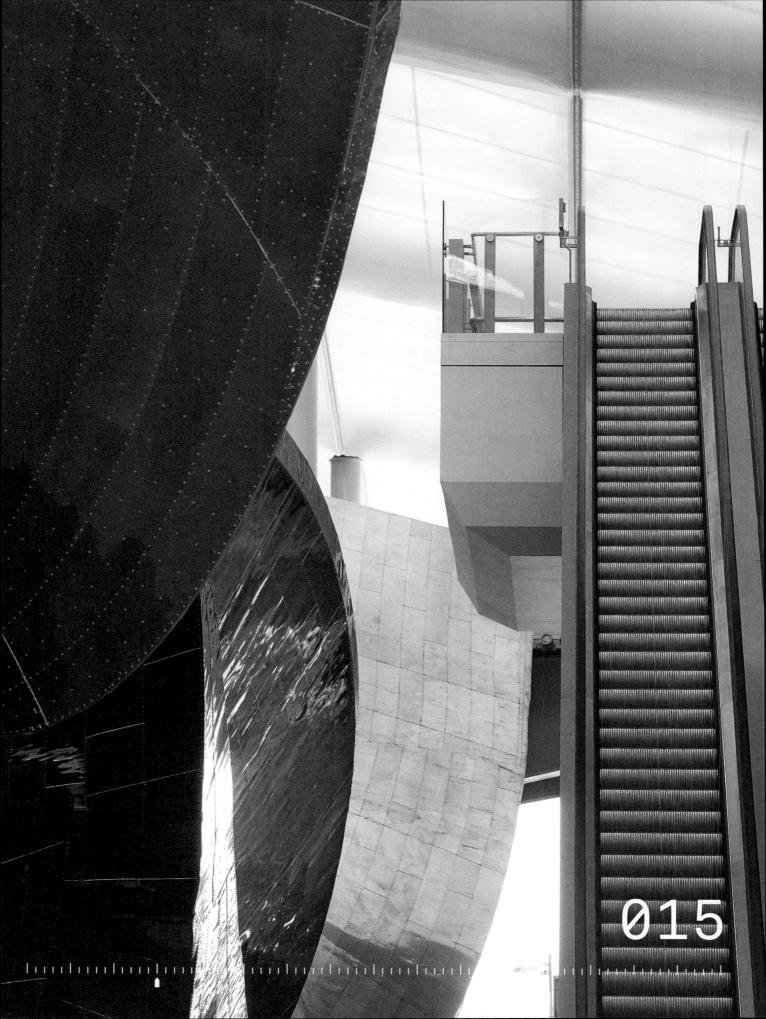

015

016

Part_No.02

Flight Path

By Jean Wainwright

With excerpts taken from interviews
conducted with Richard Wilson in 2014

'The world's magnificence has been enriched by a new beauty: the beauty of speed. The sleek flight of planes whose propellers chatter in the wind like banners and seem to cheer like an enthusiastic crowd.' *Filippo Marinetti, Manifesto of Futurism (1909)*

Richard Wilson's sculpture *Slipstream* captures the beauty of speed and flight in a triumph of abstracted form. The Cubist and Futurist artists of the early 20th century were enamoured of the new Machine Age and how to represent speed, mass and contour on a flat canvas. In the same way, Wilson engages the notion with his static sculpture's beautiful layered aluminium form, based on a plane twisting and cartwheeling through the air as if flying though clay. His is a 21st-century vision, combining process and engineering with intuition and experimentation; his undulating shapes and angles are harnessed together and tethered in space. Wilson himself says:

> '*Slipstream* makes present the special kinetic moment of travel. In the airport we flow through time, leaving a special drawing of our movements from departure to arrival, arrival to departure. Sensations of velocity, acceleration and deceleration follow us with every undulation of *Slipstream*. There are plunging shadows on the surface, there are highlights and glistening edges. It's like passing up through the clouds and into the sun.'

Dramatic and animated, *Slipstream*'s surface is a symphony of aluminium, with thousands of riveted components bathed in a mercurial passage of changing artificial and natural light; an abstraction of aerodynamic flight captured as 'motionless movement'. The sculpture engages seamlessly with ideas of 20th-century modernism coupled with cutting-edge 21st century architecture and design engineering, linking place and space in an innovative and majestic way.

> 'Think about the aircraft hangar and the aircraft sitting there on its tyres… *Slipstream* is a floating form that sits up in the air, surrounded by its architecture; it's quite at home. There are mullions and transoms on the glass, there are walkways and bridges… the whole sense of the space is of the vertical and horizontal. Within that you've got the sculpture: it's a form punched in space; it's like water rushing around a boulder; it's the aerodynamic form that is constantly moving, rather like a passenger striding to get their airplane. From [the moment you step onto] the escalators to the different levels, you are taking off. And as you glide up the sculpture, with its ascending, sweeping sheerline, rising from 6 metres to 18 metres and 78 metres long, it unfurls and evolves in front of you.'

But how did *Slipstream*, the longest sculpture in Europe, end up suspended on four slender roof columns in the Covered Court area between the car parks and the entrance to Luis Vidal's new Terminal 2 at Heathrow? And how is it that the terminal's beautiful sweeping roof works in such perfect synergy with the sculpture, turning the area into an innovative gallery space? The artistic journey from Wilson's initial inspiration to the final sculpture is, like *Slipstream* itself, a multifaceted journey peopled with different layers of expertise and artistic references. *Slipstream* emerged from numerous sketches, drawings, models, tests, fabrication and moments of intuitive magic, all riveted together by collaborative teamwork.

Wilson is well versed in challenging projects, with a history of making art such as *20:50* (1987-2010) and *Turning the Place Over* (2007). His love of altering people's perceptions of space, of 'displacing within architecture', was fostered at art school, yet there are also hints of his childhood influences in *Slipstream*. His father nurtured in him a love of making things, whether it was reading *Meccano Magazine* or buying bundles of balsa wood from the model shop to make airplanes, gliders, cars and boats devised from his own plans. A visit to see the blue whale at the Natural History Museum in London and comic-book characters such as Roy of the Rovers also left their impression on his creative imagination.

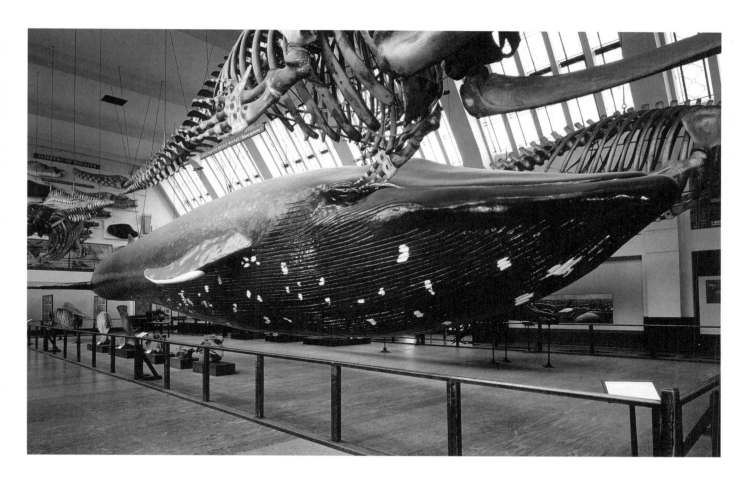

Above: Blue-whale skeleton and full-sized model at the Natural History Museum, London

'When I was a very young child I was taken to see the blue whale by my dad. It was a magical moment. I was in awe, not because of the mammal but because of the suspended *mass*. Something about the sight of this giant object was magical for me. I started to see the mouth and the eye when I walked around it and got a real sense of this *massive* floating form. It was saying, "This lives in the ocean," and I saw it swimming in that room, in that space.

'When I first began gathering images for *Slipstream* I started to look at comic books and the portrayal of movement in the wonderful *Roy of the Rovers* [who first appeared in the comic *Tiger*]. I became intrigued with the idea of animation, how a couple of lines can convey a kick of a ball or a cat skidding. I made pictorial lists going from artworks to comics and the way that abstract lines can make gestures to suggest figurative movement became a very exciting possibility. I'm not sure that it fed [my sculpture] directly, I just think it's useful ammunition because you're following a train of thought. I was making an *expression* of a movement, albeit generated within the computer, in a situation that I couldn't really do in the real world.'

It is interesting to speculate on how Wilson's training at Hornsey School of Art in the early 1970s fostered much of his experimental thinking. Discussions with visiting tutors such as Barry Flanagan still linger in his memory. Flanagan's bronze sculptures of leaping hares, with their frozen trajectories of animals caught in the act of a magnificent bound into space, were potently dynamic for Wilson. Yves Klein's *Le Saut dans le Vide* (1960)[1], with his desire to have his subjects represented by action and their imprint, was similarly influential. But it was perhaps Wilson's training in 'seeing' that left the biggest impression on him: sessions such as a two-week workshop where Wilson's drawing of a tap was redrawn and refined day after day, with guidance from the tutor, until he had correctly observed and transformed it into a tap 'that would work'. As Wilson observed, 'He [the tutor] just honed you down into looking to the point where

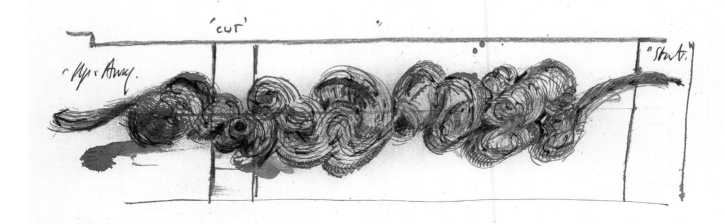

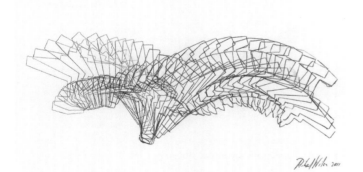

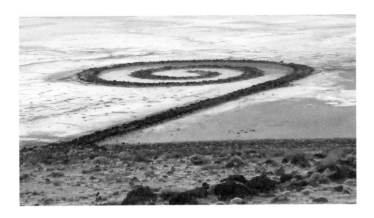

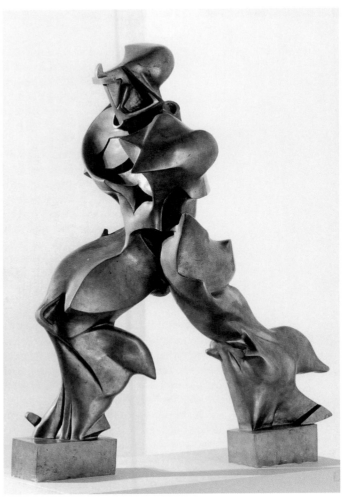

Clockwise from top: Early drawing portraying manoeuvres of *Slipstream* in a confined space, sketched before Wilson's first interview with Heathrow; Umberto Boccioni, *Unique Forms of Continuity in Space* (1913); Robert Smithson, *Spiral Jetty* (1970); outline drawing detailing the rotation of a stunt plane

I can look at things now and it helps in terms of manufacture. I can get a very good assessment not only of what the object is but how it's put together, its proportions, its weight and its temperature. My eyes really *read* a form and that's what's evolved over the past 40 years'.

'At Hornsey College of Art I looked at the American land artists – Robert Smithson's *Spiral Jetty* (1970), photographed from the air, Walter de Maria's *The Lightning Field* (1977) – and at Mark di Suvero's steel sculptures. I was looking at the American scale, which we didn't have in England in the early '70s. I loved the idea that as an artist you could work in the real world – you didn't necessarily have to have the artificial world of the gallery. I would drag people out into the landscape [to see my work] or take them to someone's property where I had made something. I wasn't rejecting the gallery space necessarily, I was just looking at other areas in which my work could be accommodated. I was investigating ideas of temporariness. I'd make a sculpture that would last one minute and it would then alter its shape. I'd do pieces that I would inflate, the tutorial would start, I'd take the bung out and as we spoke about my work it would deflate with a hiss.

'There was something during the early '70s common to art colleges, which was that one had to be unique and start thinking slightly outside the box. So the way I work now is just to go and look and jump around, seeing every aspect that's going to feed me information, then I can find my own language. I might look at another artist, or a cartoon, or a film, or listen to music or a sports item, just to get the sense of what movement is about. For *Slipstream* I looked at aerodynamics: at water going over a rock, the way a wing works on an airplane and directional arrows. All of those things were informing me so my drawing might incorporate several arrows, smudges or a couple of line marks to indicate gestures, or silhouettes that are allowed to repeat themselves.'

Wilson's idea for *Slipstream* developed from earlier experiments where he had looked at cars that had deliberately been 'rolled' during testing, which he transposed into an aeronautical context once the Terminal 2 project had been proposed. Like a hunter-gatherer he began to amass images that related to movement and flight, revisiting many paintings and sculptures that encapsulated dynamism.

'I remember trying to conjure an idea of speed and endeavour for the fourth plinth [in Trafalgar Square]. I was thinking about Donald Campbell and the *Bluebird K7*, and that moment on Coniston Water. How could I capture the velocity of the boat being propelled by a jet engine, fast and furious, down that smooth lake? I just couldn't work out how you could do that on the static plinth, this lumpen buffer that would incarcerate any movement, stop it being motion. That progressed into the tumbling car idea, which at that time didn't have a destination, which then coincided with the invitation from Mark Davy [of Futurecity] [to bid] for [the] Terminal 2 [project] and I transferred my idea to a small plane.'

During the development process Wilson revisited the ideas and concepts of early 20th-century Futurist artists, taking their love of speed and artistic experiment in the emerging age of planes and automobiles to a new 21st-century level. As the artist Fernand Léger said in 1913, 'Present-day life, more fragmented and faster moving than life in previous eras, has had to accept as its means of expression an art of dynamic divisionism'[2]. Wilson referenced works by the Futurist artist Boccioni such as *Unique Forms of Continuity in Space* (1913), an expression of movement and fluidity. It interested him in terms of how the slipstream of displaced air is attached to the bronze sculptural body shape that has been aerodynamically deformed by speed, a mechanized 'superman flying through space'. As Boccioni himself commented in 1910, he was working from the 'fixed moment to the dynamic sensation itself'.

In the *Futurist Painting: Technical Manifesto* (1910) [3], Boccioni commented on how moving objects could constantly multiply themselves, their form changing 'like rapid vibrations in their mad career. Thus a running horse has not four legs but 20,

and their movements are triangular.' Wilson also gathered illustrations of works such as Giacomo Balla's *Dynamism of a Dog on a Leash* (1912), with the blurring and motion effects in its multiplications of the walker and the dog. In Marcel Duchamp's *Nude Descending a Staircase, No. 2* (1912) he found the mechanical rendering of a sensual subject, each articulation of a naked woman's descent down the stairs linked in stop frame, her angular action containing elements that are echoed over 100 years later in *Slipstream*. Wilson's searching eye also embraced the work of the early scientific researchers and cinematographers Eadweard Muybridge and Étienne-Jules Marey. The former's 1877 sequences of galloping horses literally flying through the air, simultaneously lifting all four hooves off the ground[4], were caught by triggering the shutters of a bank of cameras and changed how artists 'saw' movement. Marey's chronophotographic gun (1882)[5] was able to record instantaneous stages of movement onto a single photographic plate. His revolutionary research included building one of the first aerodynamic wind tunnels, in 1901, to study smoke trails[6] – research that was to become an integral part of Wilson's creative thinking.

> 'I became intrigued with the idea of movement in sculpture, that notion of many moments put together, like film, somehow trying to analyse what movement is… If you leave your camera open indefinitely as someone runs by you have a lovely fluid shape. If you did the same thing on 1,000th of a second you've just got that one frozen, accurate movement. But you realise that there's many, many poses that have gone past you to make that blurred moment and that was the clue to how to approach the drawing [of *Slipstream*]: it was a case of sequential movements being laid down.'

As his primary visual reference for *Slipstream*, Wilson finally settled on a rendering of the Zivko Edge 540[7], a plane flown by the aerobatic pilot Paul Bonhomme[8] and 'probably the most aerodynamic machine in existence'. It was the aerobatics of this plane that would inform the swoops and dives of the sculpture.

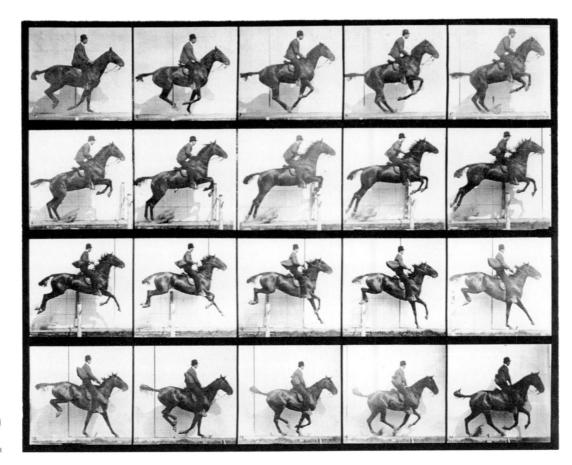

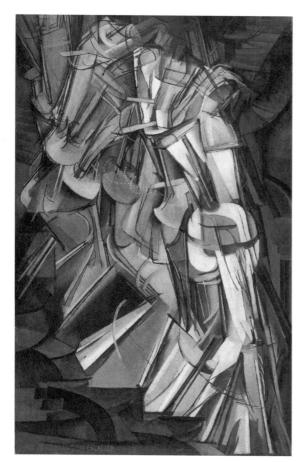

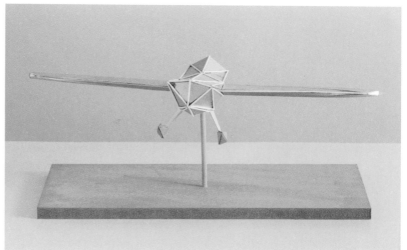

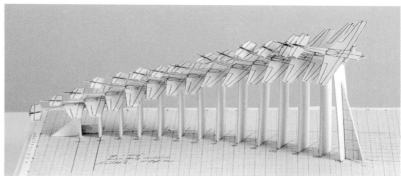

Clockwise from above:
Marcel Duchamp, *Nude
Descending a Staircase
(No. 2)* (1912); maquette
detailing static front
cone section of
Slipstream; early model
made of card and paper
describing movement of
an airplane

'I cut out paper airplanes and then I traced around them and did
spirals and cartwheels, trying to describe a tumble – or glued
them onto sticks and rolled them. I was beginning to familiarise
myself with the notion of a form going forward, made of one
shape in motion. But the problem was that however much I played
with it I was always stuck with a silhouetted form; it wasn't a
true expression of how movement can be fluid. I was also only
describing a two-dimensional form and the only way to progress
was to put the images onto the computer with the aid of the
engineers Price & Myers, who ran it forwards and backwards until
I was happy with what I had. I was manipulating [the form], making
aesthetic decisions on a flat screen about a three-dimensional
object in space. I was being asked, "What's it going to look like?"
and could only reply, "I don't *know*, but I know how to get to
something and I'll tell you when I've got it."'

Wilson described his drawing and model-making as a 'kind of mental
gymnastics or limbering up'; a way of focusing his mind and 'clarifying his
thoughts' prior to explaining them to a team of fabricators at Commercial
Systems International (CSi) and engineering firm Price & Myers, who would
make *Slipstream* a reality. On his drawings Wilson used lines to describe
the way the rivets worked or to accentuate the flow of forms, and colour to
highlight 'particular elements' or to emphasise areas that he wanted to notate
or talk about. For Wilson, drawing has a triple purpose: the 'sheer enjoyment
of it, observation and idea generation'. On paper he worked through numerous
permutations of the shape for *Slipstream* but when it was mocked up as a 3D
CAD model he was surprised at the misinterpretation. In a eureka moment
he placed a model plane in a hamster ball and rolled it along the floor to
demonstrate his idea; as the object twisted and turned inside the transparent
ball the team realised that this was the idea.

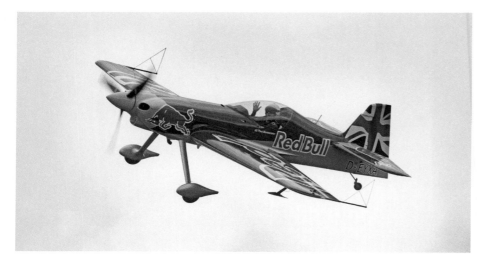

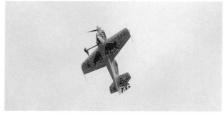

'The hamster ball was placed on a clear plastic mount and then a camera aimed at it. I did a whole series of photographs of turning that ball. The airplanes were glued down on paper and then the wing tips were joined. It began to evolve – the sense that the sculpture would corkscrew and roll and undulate, and that you were creating aerodynamic fluid movements. Suddenly, however, the practical solution to making the form became much more complex: you now had 360 degrees and many different permutations and possibilities. When I looked at what had been produced on the computer from the images I thought that it really pushed the aerodynamic boundaries. However, the stunt pilot Paul Bonhomme was able to demonstrate that the plane *could* do many of the manoeuvres. He picked a sequence of moves and linked them together; it's like taking a sentence and removing some of the words – and then what you're left with, he managed. He was very clever because he achieved it through gravity. He cut his engine and dropped. When the plane is falling it can do a lot more… gravity can allow it to spill backwards onto its tail and flip over, and then you can put the engine back on and it comes out of its dive.'

Wilson could now visualise the sculpture. But turning the 78-metre, 77-tonne fluid form into a reality and fitting it into a space designed long before *Slipstream* was conceived represented a complex engineering and architectural challenge that required amazing ingenuity on the part of Wilson and the team of experts he had put together at CSi and Price & Myers. This was no ordinary sculpture: the design and fabrication were complex and its sheer scale meant that it had to be constructed like a building, quite apart from generating a form that captured the

movement of an airplane tumbling through space on a trajectory. The engineers used cutting-edge, pioneering computer-aided technological methods to realise it.

The materials used in *Slipstream* were key, the multiple demands of construction, engineering, budget and maintenance all having to achieve consistency with the aesthetic ideal of Wilson's creation. The aluminium skin needed a coating, both in order to best articulate its 'flying surfaces' and to make it durable. The glass-powder coating finally decided upon was the result of various experiments until a compromise was reached. As Wilson describes it: 'The surface relates to airplane history, such as the classic Douglas DC Series finish. It's shiny but you'd never see your reflection in the powder coating, which is basically a baked-on coat. It's also an animated surface in an animated space which – being partially reflective, partially polished – draws light to it and holds it on its surface. The surface zings.'

Because of its huge scale, and the need to transport it down the motorway from the CSi construction site in Hull to Heathrow, *Slipstream* had to be constructed in 23 sections. Each section formed part of a complicated engineering puzzle, the steel armature (framework) anchoring plywood bulkheads that sub-divide the plane's total movement into sequential moments. Wooden ribs spanning the bulkheads support a double-laminate of plywood that, Wilson explains, 'defines the outer complex form of the sculpture'. This sheathing of plywood is then clad with the finishing surface of aluminium panels and riveted to the plywood, giving the 77-tonne mass an elegant, streamlined appearance. Commenting on the architectural and engineering challenges faced in bringing Wilson's creative idea to life, Ralph Parker, RIBA architect from Price & Myers, said, 'It's *air* that we're encapsulating here, then dressing it in this beautiful airstream language of aviation history.'

Below: Structural engineering renderings from Price & Myers showing cassette profiles, created in 2011 prior to construction

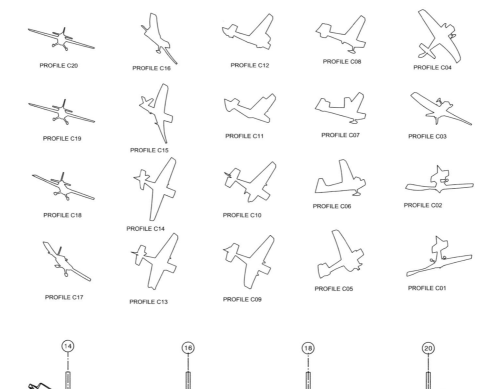

PROFILE C20 PROFILE C16 PROFILE C12 PROFILE C08 PROFILE C04

PROFILE C19 PROFILE C15 PROFILE C11 PROFILE C07 PROFILE C03

PROFILE C18 PROFILE C14 PROFILE C10 PROFILE C06 PROFILE C02

PROFILE C17 PROFILE C13 PROFILE C09 PROFILE C05 PROFILE C01

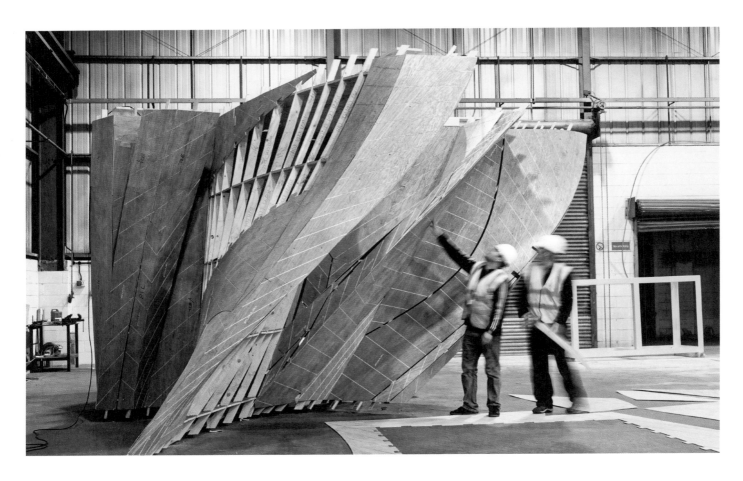

Above: Fabricators with a section of *Slipstream* under construction at CSi factory in Hull

'The pop rivets were completely practical but they became a way to articulate all the flying surfaces: they work really well for the sculpture and they really delineate. So these rivets emphasise points where the form is undulating and changing and toppling within itself, the places where it folds and rolls; rather like the way a wave folds over itself and bits bubble up and over, or kneaded dough. The contoured shapes that occurred are like smoke billowing around; its like fluidity and ephemerality becoming a structure. It's quite an interesting thing to do. It's like saying, "How do you make a structure out of smoke? How do you *build* that?"'

The aluminium is the top surface, the cladding — visible to the public in the same way as the skin on our bodies is external. However, Wilson points out that what we don't see is a whole other world that's been engineered to make that 'skin' stable and to make the structure stand up.

'Like a sliced loaf, 71 bulkheads are fixed on a steel framework running the length of the sculpture. Ribs straddle around this series of shapes forming a sophisticated surface, onto which sheets of ply were clad. This wrap of ply formed the canvas onto which the outer aluminium skin was fixed. As each cassette was built, fabricating at the factory became easier — but the challenge was the install at Terminal 2. There was no actual prefabbed way of dealing with the shape between two cassettes that met at each column fixing; these four areas were specifically crafted on site. An abseiling team hand-finished the joins at each of the four columns.

'I've always worked with what's given; I look for visual stimulation from the site. *Slipstream* is rooted in its location. The work is a metaphor for travel; artwork that moves in time and space.'

It is difficult to imagine the excitement, highlighted by Robert Hughes in his 1980 art-history critique *The Shock of the New*[9], at the advent of mechanisation and transport innovations in the early 20th century: 'For the machine meant the conquest of horizontal space... the succession and superimposition of views, the

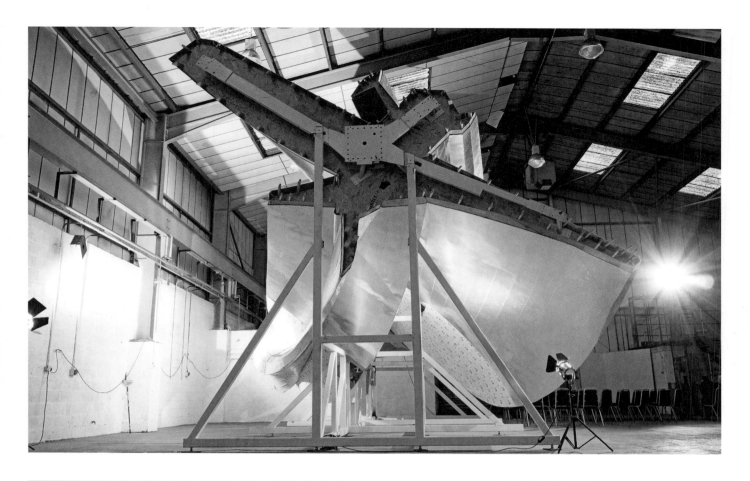

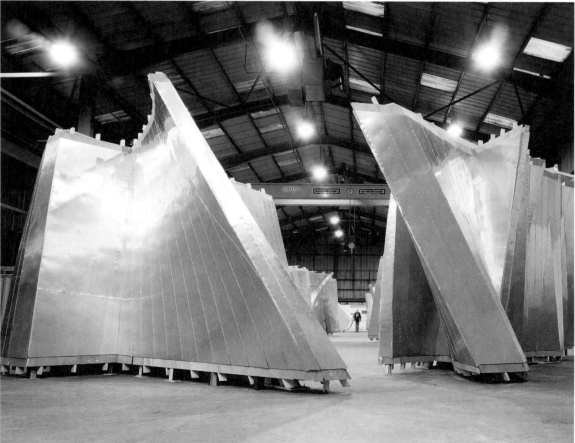

Above: Three connecting cassettes being put together for the first time for a factory presentation in Hull. Left: *Slipstream* production at Hull factory prior to delivery to Heathrow

027

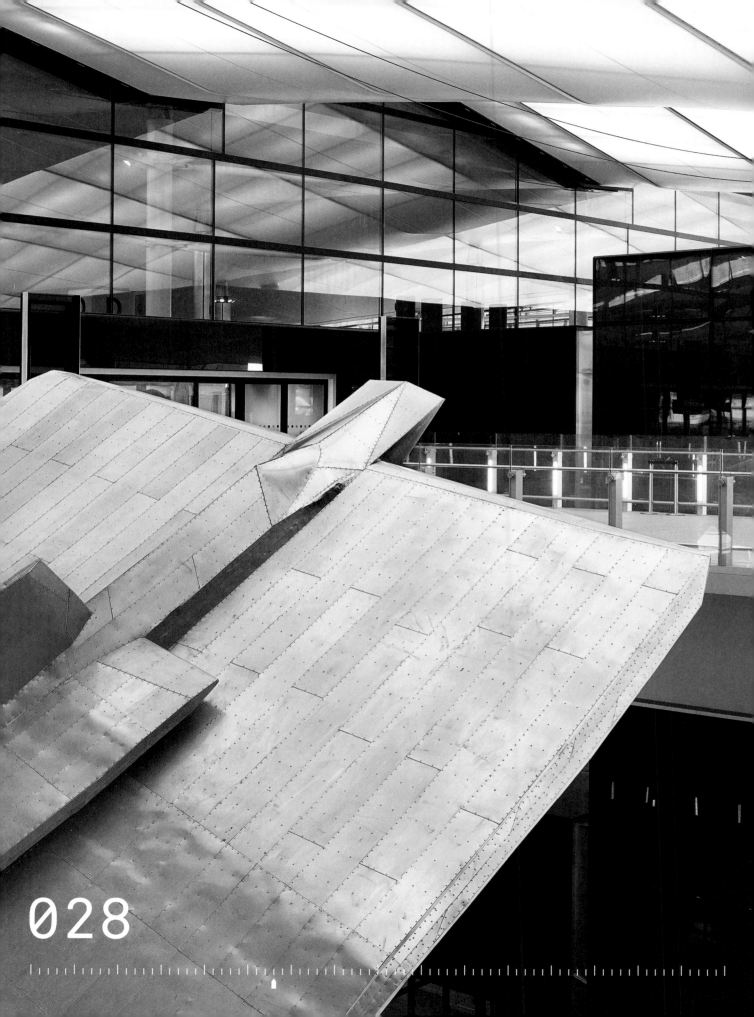

028

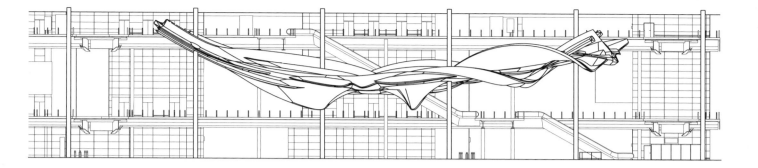

Above: East elevation cutaway showing *Slipstream* in context. Opposite page: Detail of the front end of the sculpture

unfolding of landscape in flickering surfaces as one was carried swiftly past it.' This excitement is renewed in *Slipstream*. As you move through Heathrow's Covered Court from your car or the train on your way to the plane, or from the plane to your ongoing transport, ascending or descending to the various levels, you are seeing reflections in the glass windows, the furled ceiling with its edges coloured with concealed light. The different nuances of the shape, form and contour of *Slipstream* 'start playing', Wilson suggests, 'against the grid of the windows like a drawing on graph paper'. This is not a work that has been imposed on the architecture but rather one that breathes with it.

> '*Slipstream* is a work that floats above the floor and is unlike anything I have done before. In fact, I remember when I was a student in the early 1970s I wrote my student manifesto, which was things 'not to do' as a sculptor. It included statements such as "Never suspend a work" – which is what I have done!'

You can sit on the marble slabs at ground level under the monumental structure and see the planes taking off in your peripheral vision. *Slipstream* links the sky with the ground in a sculptural manifesto for the 21st century. Just as the blue whale of the Natural History Museum has a trapdoor in it containing coins and a telephone directory, so the nose of Wilson's sculpture has a secret compartment housing a scroll of the people involved in its making, and visual records of its extraordinary journey to Terminal 2.

'The new life of iron and machine… the glitter of electric lights, the whirring of propellers, have awoken the soul.'
Kasimir Malevich, 1916[10]

1 Translated as *Leap into the Void* (1960).
2 Fernand Léger. *The Origins of Painting and its Representational Value*. Originally published in Montjoie, Paris 1913. Reprinted by Charles Harrison and Paul Wood, *Art in Theory 1900-1990*. Blackwell 1992, p198.
3 Umberto Boccioni, Carlo Carrà, Luigi Russolo, Giacomo Balla, Gino Severini. *La Pittura Futurista: Manifesto Tecnico*. Poesia (Milan), February 11, 1910.
4 Muybridge wanted to share his groundbreaking work, which led to him inventing the zoopraxiscope in 1879 where he projected animated versions of his photographs as short moving sequences.
5 The chronophotographic gun could take 12 consecutive frames a second.
6 In the 1890s, Marey laid small silver-coloured balls made of wax and resins in water agitated by means of a propeller and recorded them photographically. It was this that gave him the idea of making a similar experiment with wisps of air produced by a wind tunnel.
7 The Zivko Edge 540 manufactured by Zivko Aeronautics is capable of a 420 degrees-per-second roll rate and a 3,700 feet-per-minute climb rate.
8 Paul Bonhomme was introduced to Richard Wilson by Mark Davy. He is a British aerobatics and commercial airline pilot (flying for British Airways). Bonhomme is part of Team Bonhomme, the world champions of the Red Bull Air Race World Championship.
9 Robert Hughes. *The Shock of the New*. BBC Publishing. 1980, p12.
10 Ibid. Hughes p170.

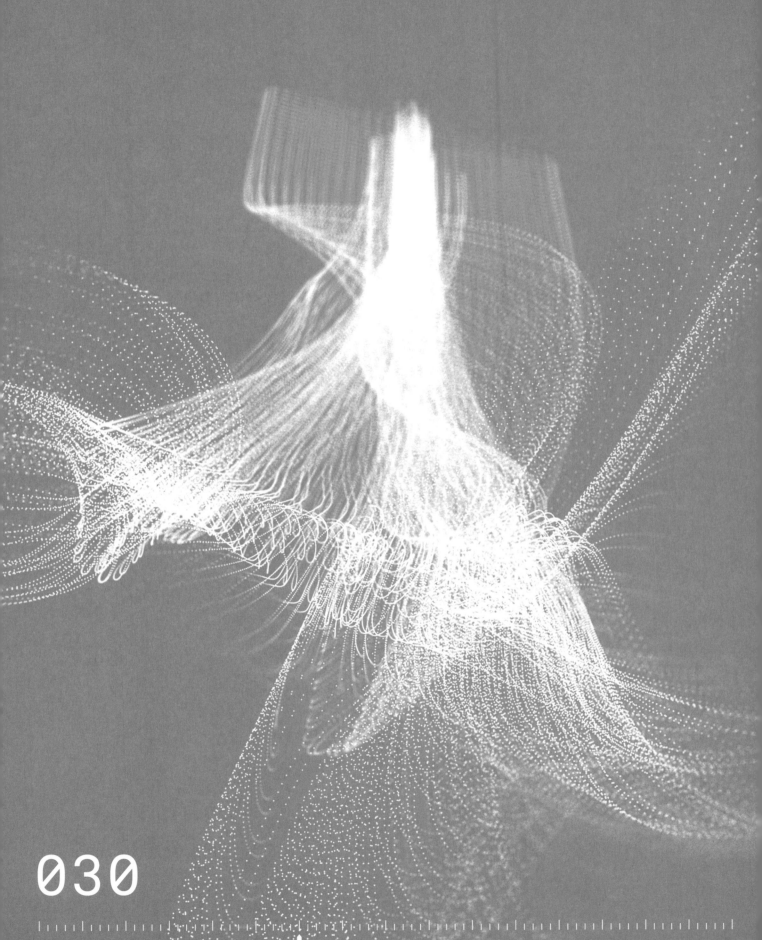

030

Conversation Piece

By Jean Wainwright

Richard Wilson's 'Slipstream' sculpture is a stunning addition to Heathrow's Terminal 2. Here the artist takes part in a roundtable discussion with the rest of the team behind the piece, revealing the creativity, architecture and engineering involved in crafting an artwork that will be seen by 20 million visitors per year.

Jean Wainwright No sculptural project on this scale could ever happen without the collaboration of a huge number of people and this discussion brings together the team responsible for making it a reality. So starting with you, Mark, as curator: how did the *Slipstream* project come about?

Mark Davy Well, in 2010 we were approached by Grimshaw [Architects], who were working with Heathrow. Originally there had been some discussions about a landscape scheme for the new Covered Court at the new Terminal 2, which was proving problematic. We were asked to come in and meet Heathrow to talk about an alternative. We were talking about the way the Millennium Park works in Chicago, and particularly the Anish Kapoor piece [*Cloud Gate*, 2006]: it's a sort of gateway sculpture. We suggested that as London's premier airport and a gateway to London – and with London being a cultural city – Heathrow should perhaps consider a sculpture competition, or arts competition, that played with this void. So this got an interesting response and we were sent off to do more work. Then we found out that the volume of the space was not far off that of the Tate [Modern] Turbine Hall. So you had this opportunity to almost replicate the [Tate] Unilever Series, where artists make a proposal for the space. This eventually turned into a competition in which five artists were selected to make a proposal.

Jean Wainwright Now that's an interesting process, because then the artist has to come up with something that's viable. So, Richard, you were one of the artists selected for the competition. How did your ideas come about? Because you won it, of course, and your work is now installed in Terminal 2.

Richard Wilson Well, coming up with ideas is quite easy but getting them to sit properly in a space is difficult. I had an idea that I'd been working on since 2010, with which I had been having a lot of difficulty in knowing how to realise: a tumbling car. When the competition was first announced to me by Mark and I was shortlisted, I just transposed the idea of a movement into my thoughts towards the airport. Of course, in terms of making it poignant to the location it meant that the car idea was not suitable, so what was the potential of an aeroplane? And so the sketches started and from there I took it forward as a proposal.

Jean Wainwright At that stage you had to start making models. Is that where you came in, Tim and Ralph, in terms of making Richard's ideas come alive?

Ralph Parker Richard came to us at the end of that summer in 2010 to talk about this job – it really captured our imagination. What was particularly interesting about it from both an architectural and engineering point of view was that it's something that hasn't been done before. It's completely pioneering, generating the shape of a volume – in this case an aeroplane – as it moves through space on a trajectory. Of course we said we could do it but did a bit more research and realised that mathematically speaking it's really at the cutting edge of what is possible. And the size of it also represented an engineering challenge.

Tim Lucas It's a very large sculpture and the final piece was hard work at 78 metres long. It weighs 77 tonnes, it's as long as the wing span of a jumbo jet and is supported on columns – in a space that wasn't designed to take it [on columns] – that were already there before the competition was even conceived. It was certainly a challenge. How to actually create the aluminium surface was one thing but then we had to consider how to, for instance, take the weight of a rivet that's on that surface and transfer that through the sculpture and down those columns into the ground.

The Panel

Jean Wainwright **Art historian/ writer/moderator**
Richard Wilson **Artist**
Mark Davy **Director of Futurecity;** *Slipstream* **project curator**
Maarten Kleinhout **Commercial Systems International (CSi);** *Slipstream* **project manager (production and installation)**
Tim Lucas **Price & Myers; partner in charge of project /engineer**
Ralph Parker **Price & Myers; architect**
Andy Weber **Project manager, Heathrow Airport (Terminal 2 Landside Projects lead)**

Left to right, top: Ralph Parker and Tim Lucas. Left to right, middle: Andy Weber, Richard Wilson and Jean Wainwright. Bottom left: Mark Davy. Bottom right: Maarten Kleinhout

033

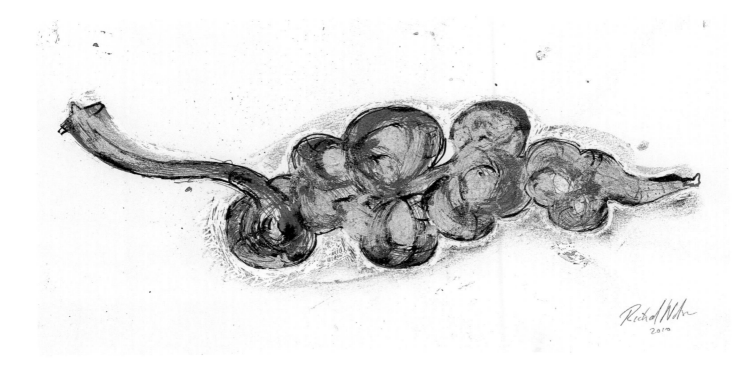

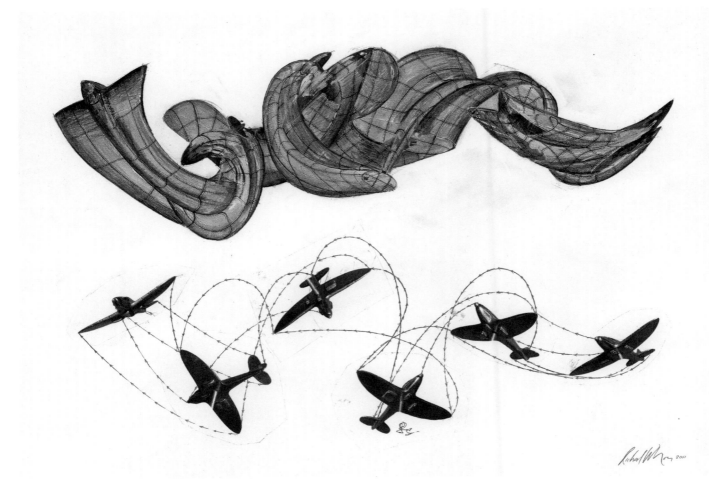

Top: Informative stage drawing in response to brief.
Above: Early drawing to define movement of an
airplane in a single form, prior to Heathrow interview

Actually creating a way of making it that allowed it to be held together, made in a simple way that we knew we could realise with the technology that was out there and with the contractors that were in the construction industry, was difficult. It's a sculpture but it's conceived in a construction environment and that's a very important thing to realise: it's not cast in steel so it's actually made like a building that looks like a sculpture.

Jean Wainwright You have worked with Richard several time in the past, on *Watertable* (1994) and most notably *Over Easy* (1999) and *Turning the Place Over* (2008). So already you knew his personality, his aesthetic and his working method. I'm intrigued when you say, 'Of course we said we'd do it.' At some stage there were some small models and some sketches that obviously landed on your desk. Did you not think, 'Oh goodness, how are we going to do that?'

Ralph Parker We knew from previous experience that this project was going to need a computer to manifest itself and that's not just from a form-generation point of view but from the sheer scale of it. The sheer volume of pieces meant that there was no way it could be done by hand. Just how big it was and how much time and investment of energy it was going to involve was perhaps not realised but that pushed everything forward. It's a pioneering project.

Jean Wainwright Of course, Maarten, you also had the challenge of how *Slipstream* was going to be fabricated. At what stage did you see the computer drawings and the models?

Maarten Kleinhout Richard established a team very early in the day. In fact it was prior to us making the initial presentation to get the commission, which is a very brave and clever decision if you want to move into an idea with the minimum amount of disruption. So he had the confidence in Price & Myers and us [CSi], because of past experience, to deliver this artwork. What we brought to the table was a set of projects that we had developed previously where there was a real drive towards the use of digital, three-dimensional work to generate some sort of process that would allow the digital model to translate into physical form. And a lot of that technology was clearly enhanced on this project and taken a stage further. I think all those discoveries from previous projects came together on *Slipstream*. We were swept away by the same wave: it was a *fantastic* job to be involved with, frightening to some extent, but we did actually have to build it and the levels of reality and physicality crept their way in through the back door. I think if you were to spool back a bit, if we'd known the hurdles we'd have to go through I wonder whether we would actually have had the courage to take it on. But it's been a very interesting, inspiring journey.

Jean Wainwright Heathrow's Terminal 2 is an enormous project and this is an enormous sculpture. Andy, can you talk about Heathrow's role in the project and about the collaboration with Futurecity?

Andy Weber We had the challenge of what to do with the space between the car park and the main terminal. Everything we really do here is about the passenger experience and in Terminal 5 we had the same challenge – and dealt with it by using landscaping. But here the challenge we had was that the physical way the buildings come together meant that the landscaping wouldn't work and the plants would die, so we had to come up with something new; in this case, an artwork. Public art is something that's not particularly new to Heathrow – we've got examples in a number of our other terminals – but we've done nothing on

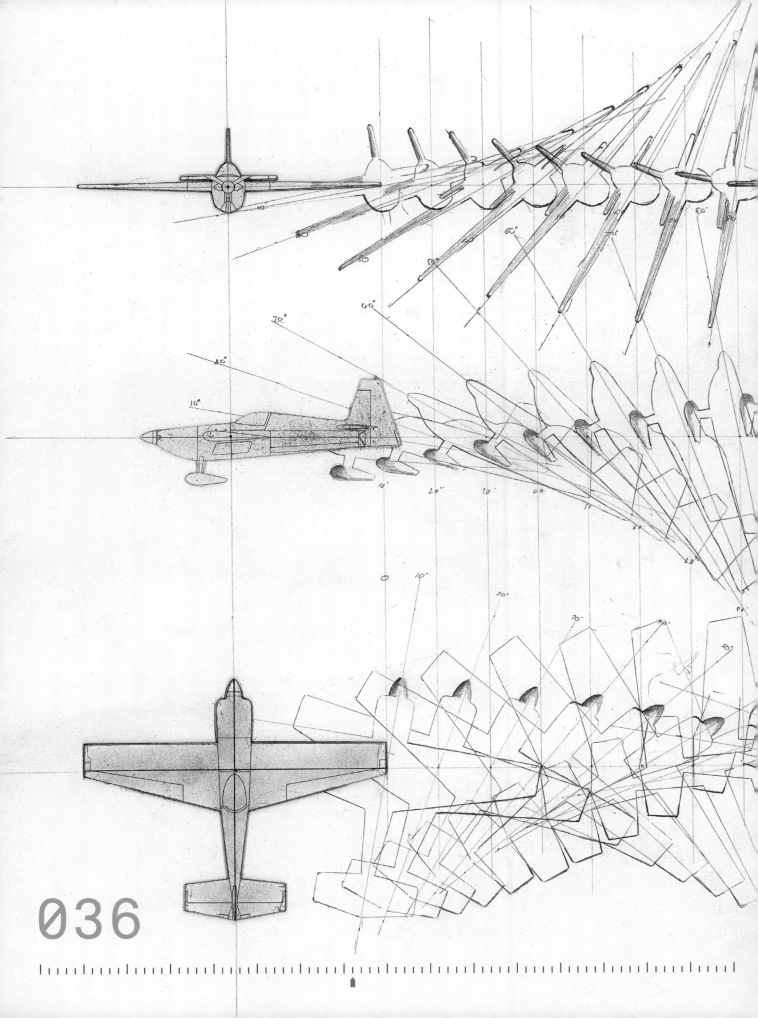

036

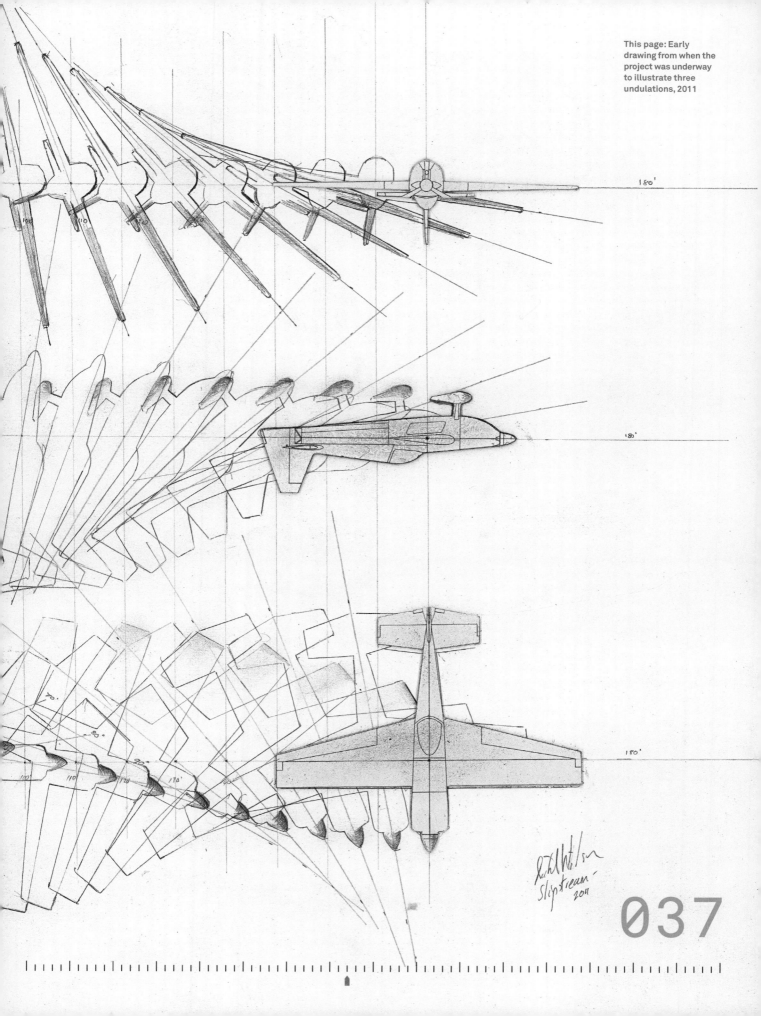

037

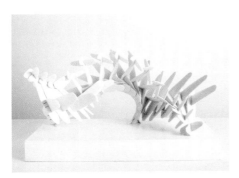

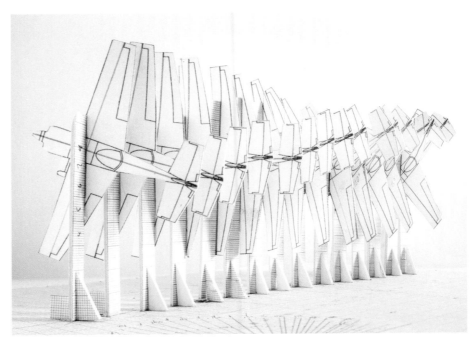

Clockwise from top: One of the first models of polystyrene airplanes glued together, made just after Heathrow interview in 2011; early model of card and paper describing movement of an aeroplane; model showing undulation between two positions – wood and silver paint give the illusion of aluminium, *Slipstream*'s ultimate finish

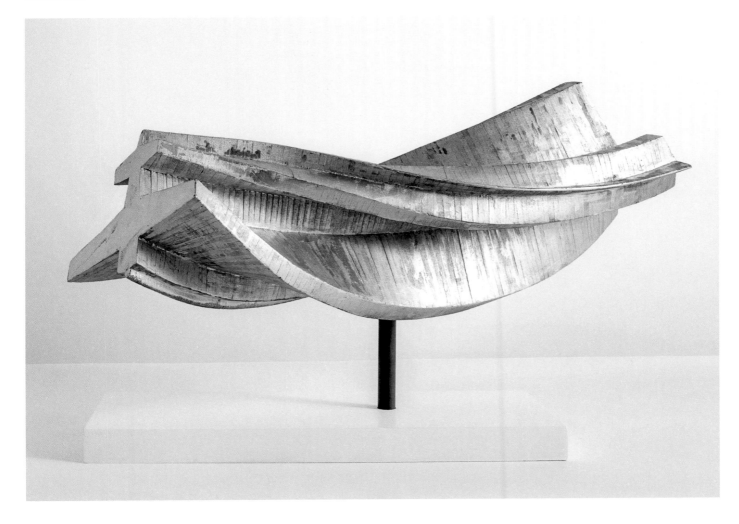

this scale. There aren't many people who have done anything on this scale so to take on something like this took some brave decisions by some senior people, guided through the process by Futurecity. Continuing what Maarten said, the team was really important. When you're taking on something that is potentially risky because of its scale and complexity, one of the greatest things that you can get is a team of people who have worked together before, who trust and know each other and can come together and tell you everything's going to be OK. It gave us great confidence that this project would turn out well.

Jean Wainwright There is also something magical about *Slipstream*, which captures people's imaginations. Richard, can you talk about some of the wonderful experiments you did to get the form, shape and the flow of this sculpture?

Richard Wilson It's interesting: I've never been confounded in a situation where I couldn't make a maquette. I could make some very good guesstimates about what *might* occur but in order to actually see it… I could go as far as explaining to the experts what I was *trying* to get at but it was only in the virtual world of the computer that you could actually see it happen. That was a first for me in almost 40 years of manufacturing. I've never had a situation where I can make a loose assessment of something but not actually be able to graph it and say, 'That's what I want.' It was a case of suck it and see. What I could do was make assumptions, make sketches; I could set up experiments taking a paper cut-out into a three-dimensional situation that I could keep moving and photographing. I could do lots of things that circumnavigated the nucleus of what this thing was going to be but I couldn't make the nucleus. It meant that the whole team was kind of working together to try and find what that was. What was interesting was that I had gone as far as I could. I remember the very first email back from Maarten at CSi, which said, 'We've solved how we're going to make it', and it was this one silhouetted piece that was kind of linked, and the thing was flying around. And I thought, 'Oh God, that's not what I want!' And that's when I had to go and buy a hamster ball. We met at Price & Myers and I rolled it and said, 'Look – it's something like the way that goes along that track. It's not *flying*, it's an object that's thrown, like a plate might be thrown. So it's going to do what an aeroplane normally wouldn't do but at the end of it, it will.' But I couldn't say, 'It's going to look like this,' I could only say, 'You see that? It's something like that.' It was only when we started to experiment in the [digital] world, where you can see things and they leave their trace behind, that we could get a sense of something that we all do every day when we get up and go to work: we leave a trail through air. If you packed the world with clay, we'd all be making holes like worms do underground. I was just doing that in a big empty space and saying, 'Look, we're all worms: so is that object.'

Maarten Kleinhout I've been looking at the original sketches that we did in the very early days, Tim, maybe three or four years ago. They were illustrations of initial drawings and yes, it looked like an aeroplane.

Tim Lucas And if you look at the sculpture now it looks nothing like that! But we assumed then that the rough form would be a plane. The projects mentioned earlier that we'd worked on together previously were timber roofs of buildings. But the technology of interlocking timber parts that we've used to build this was something we pioneered on this sculpture. We thought that that would be a good way

Above: 'Airplane hamster ball' model made out of acrylic and card, created to capture a series of photographs to help inform Richard's drawings

to form that kind of aeroplane shape with wings: a central body that would hold a structure, that could hold the thing up between the columns. But actually getting to that shape was something that was in the world of animation.

Ralph Parker We knew we wanted this tumbling form and that *Slipstream* was going to have all kinds of strange shapes but in the beginning we couldn't visualise either – we had to do a lot of research and development. So we started off with a program that's normally used in film animation for doing CG effects and Richard and I sat down and we planned the motion. You do it as if you're doing a stop-frame animation and it interpolates between the points to give us the motion. We ended up with over 50 different iterations of it but at the very beginning that was how we set up the motion. I always described it as 'acrobatic' rather than 'aerobatic' because at the time we didn't think – although we were later disproved – that it could possibly be a shape any plane could replicate.

Mark Davy That's the interesting thing about life: it's sometimes not as good as art. In this case, when we did eventually get the Zivko Edge 540 to go up in the air to try and replicate the tumbling plane [flown by Paul Bonhomme], it took about 15 miles to do what Richard and Price & Myers had managed to squeeze into the length of the auditorium, the action space. So what was interesting was that it was a purely sculptural idea made real – made cartoon-like almost, in that the reality was far more stretched out.

Richard Wilson I think that the whole project is a metaphor for the history of flight: I think I'm Orville Wright [aviation pioneer] and I'm there with my quill and canvas – and yet we've ended up in the cockpit of a jumbo jet through the process.

Mark Davy It's interesting, bringing it back to Heathrow, because at the same time that you were developing the sculpture, internally at Heathrow there was the same amount of discussion about what they'd actually taken on. Because at the beginning there was a sort of glamorous quality to the whole thing and everyone was involved, at director-level, brand, marketing, operations… I think when we interviewed the five artists there must have been 20 or 30 people in the room from Heathrow – we set up two big rooms and the artists came in with their teams. I remember Richard coming in with Ralph, Tim and Maarten and there was a burst of energy that came into the room. I'm sure they weren't wearing overalls but it felt like it at the time. They were ripping boxes open, maquettes were coming out and everyone was kind of manoeuvring. And I think we were just blown away by the energy. But after that was over and the bits of paper had settled back on the table and we'd put the glasses straight, there was a lot of work for Heathrow, I think, to actually figure out whether this could really happen.

Richard Wilson I think working in the public domain you have to give up on a certain amount of your idea. That's the natural thing – you've got to make things safe, you've got to make them stand up. I had to work with what was do-able. I mean *my* world is very ephemeral – trying to get at an idea – and it is only when it's planted down by the engineers and crunched as numbers to make sense of the form that you then have the reality of it. We had to think about the fact that this space wasn't an interior but at the same time it wasn't an exterior. But that meant that during moments in the year there would be saturation points in the atmosphere and then it would be very hot and very cold. You have to go with the situation where the material works and will stand up to the test of time. So all the time it's a learning curve.

Jean Wainwright Andy, what about the actual experience of the sculpture: this is going to be seen by 20 million people a year from all different vantage points, which is pretty incredible. Has it fulfilled your expectations?

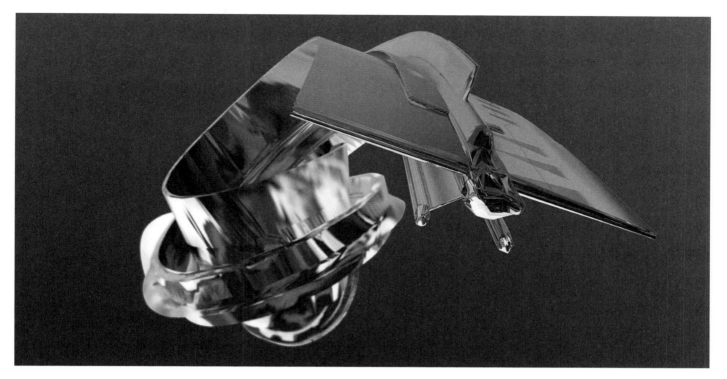

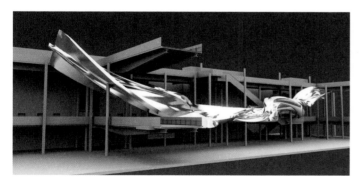

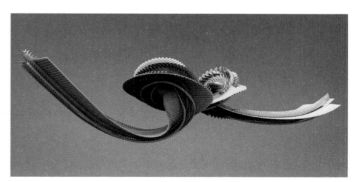

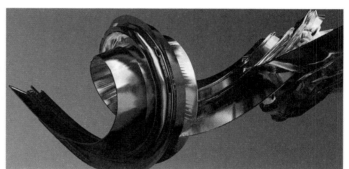

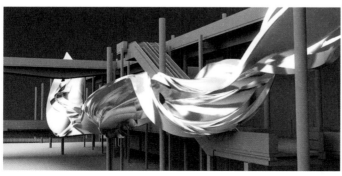

Top three images and above: Early experiments in form generation. Left and above left: views of prototype number 20 (of 49 total versions) of *Slipstream* visualised in the context of Heathrow Terminal 2

041

042

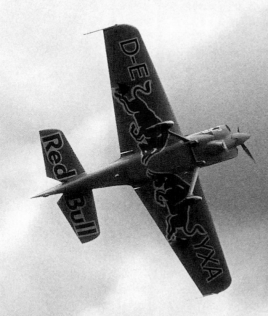

This page: Edge 540
Redbull stunt plane
performs *Slipstream*
acrobatics at Audley
End airfield, 2013

043

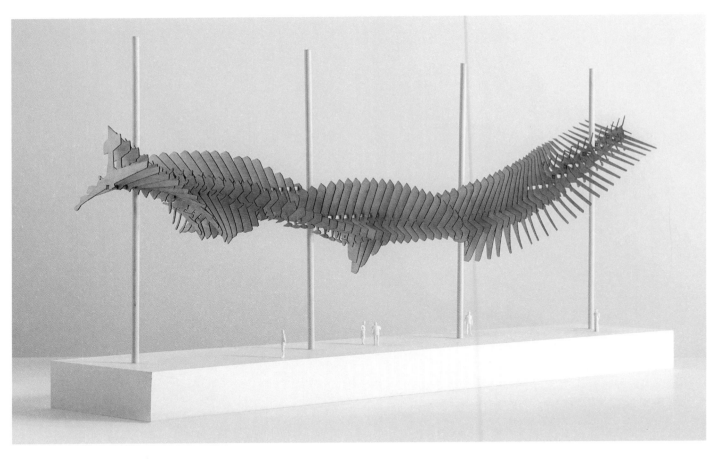

Andy Weber For me, when you walk through that space at all the different levels you never get the same view of *Slipstream*, however many journeys you take. Twenty million passengers a year over 50 years: that's a billion people who will ultimately go and see it and walk past it, either going in or out of the terminal. And then there's the staff, who are constantly there. Even with the construction workers there was the initial excitement, knowing that the installation was about to start on site. Every time I went I was questioned on *Slipstream*'s progress: 'When does the first piece arrive?' 'When are you going to finish the first beam?' 'When are you going to finish the whole thing and put the front on it?' I'm biased, obviously, because this is a project that I've been looking after – but for me, in the journey that the passengers will make, whether they're departing or arriving at Heathrow, this is the standout moment – going through the Covered Court and seeing *Slipstream*.

Mark Davy It's hard to exaggerate actually how radical this is. There aren't really that many big pieces of public art and when they are big they are mostly standalone pieces. [Anthony] Gormley's *Angel of the North* is a standalone, fabricated piece in the landscape, and Anish Kapoor's *ArcelorMittal Orbit* tower is the same. So to add such a radical public artwork that does not come out of the normal, conventional commissioning process… This is not public money, this is not the Arts Council or a Regional Development Agency – this is Heathrow being very creative.

Jean Wainwright How important will it be for *Slipstream*'s audience to realise the huge amount of artistic research and development that has gone into it?

Maarten Kleinhout In the factory environment we were privileged to see every aspect of the work. From the moment you get a drawing coming through your door to the moment you get your first CNC-produced material into the factory, then your factory workforce assembling it, welding it, checking it – you actually start realising the geometry. All those little bits and pieces come together. Actually, it's

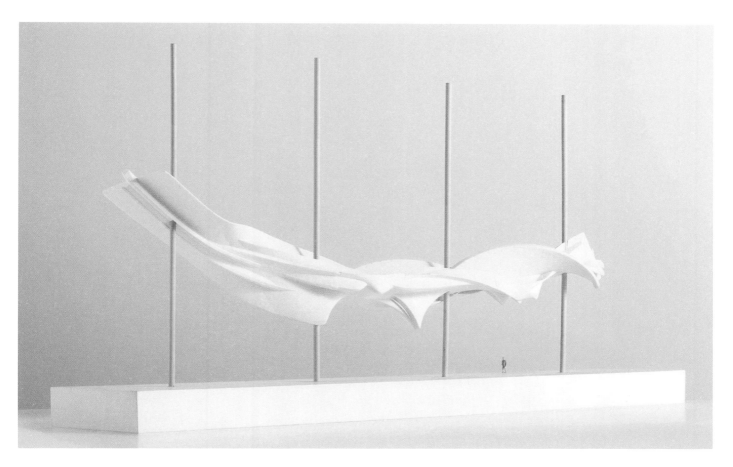

Above: Scale model of *Slipstream* from 2012, 3D printed at 1:72 scale, which is the standard scale used in the airline industry. Opposite page: 2012 Maquette detailing the 91 bulkheads that make up the segmented inner structure of *Slipstream*.

creating volume. And then you clad the volume and when you hit problems, initially you wonder, 'How do we get round that?' And then you get dialogue. Then gradually this thing gets more and more like the vision you have of it, and then it comes to site [at Heathrow] and you've got these 23 bits. And the great thing about the volume as you say, Andy, is that it does change: with the light, with the way you approach it. And because [as a passenger] you are part of a journey, the question is whether you stand and watch it or whether you just walk past. But every time you walk past it you will get another little moment you didn't think existed before.

Mark Davy There are some fantastic accents in it. The two for me are the reflection in the glass, which is really amazing – when you suddenly catch sight of this Leviathan, this kind of beast slumbering in the glass – and then you get the diagonal escalator that cuts up right past it. You can actually run your fingers along the side of it. That's incredible; it's extraordinary. I can't think of a sculpture where you've got so many entry points, such theatricality.

Richard Wilson So really your journey starts at the point when you get off the bus or get out of your car and go into that space and you come across that sculpture: you're starting to be informed already about your journey, your flight, by *Slipstream*.

Ralph Parker The one thing you'll never have on the computer is the sense of scale. So you can zoom in on a rivet until the rivet's the size of the screen, or zoom out until the whole thing is the size of a pixel, but you'll never get a sense of what it feels like. Sculptures have that power to interact with you on a corporeal basis. They speak to you as an embodied being and when you're there in front of it it's huge, it's incredible. And I think the other experience I am quite pleased about is when you're in the terminal building looking back, because that's the only point you can get far enough away from it to see it in its entirety. It feels like this huge whale floating in a tank.

045

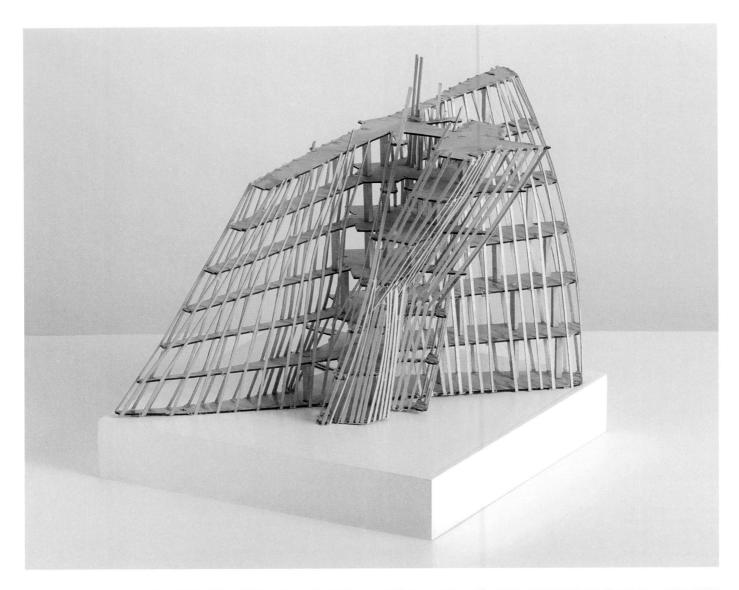

Above: Unfinished
scale model of cassette
incorporating bulkhead
and combs, pictured
in an upright position
(not the correct
horizontal position).
Right: Price & Myers
drawings detailing
laminate and fastening
of the aluminium
skin. Opposite page:
Sequential development
of a single cassette
from steel armature
to aluminium skin

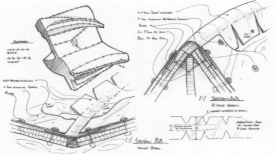

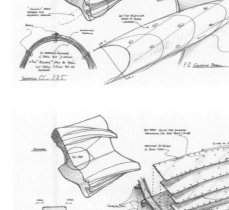

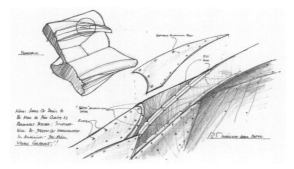

Mark Davy For me, what I think has been interesting is that you are in London and it's by a major London-based, British artist. It's about flight and the excitement of flight, and the thrill of the air show, as Richard described. But it also links into other ideas about Britishness and the other British brands, if you like, that are involved. So it's sort of all brilliantly joined up. Ultimately, if you're a passenger coming to London, what makes it London? What makes the link from the airport to London, the city? What is the link? I think what Richard has done is created that link.

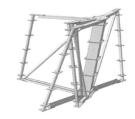

Jean Wainwright The materials are vital to this piece in terms of light. How will it be maintained and how do you think it will look over the passage of time? This is a permanent sculpture and often not enough attention is paid to how a sculpture ages.

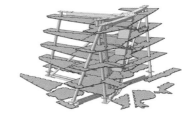

Maarten Kleinhout The choice of materials is obviously driven by aesthetics and engineering. Going back to previous projects with Price & Myers, we have gradually explored the qualities of sheet materials and what you can do when you start forming them, the strength you get when you start forming in three dimensions. However, while on *Slipstream* you could use sheet materials to some extent to get some sort of stress skin, to use that sort of structural property you also had to span the columns. You had a bridge-structuring effect between four columns in total that had to carry all this material, carry the form and keep it on the centre line of gravity on the columns. The chosen material for that was steel. Beyond that we used many of the construction principles we used in the other projects.

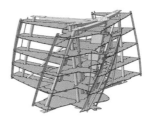

Ralph Parker The approach we've taken is not normally what you'd do with a sculpture. Sculptures tend to have their own bespoke and expensive construction methods but because of the sheer size of this we effectively treated it as a combination of a series of bridges – from a structural point of view – and a roof, from an architectural one. To get that we kind of half-hitched a great deal of technology that isn't too far removed from the golden era of aerospace technology. We used a series of bulkheads that describe the form and then spars – how the Spruce Goose or a Mosquito would have been constructed – with a continuous 'stress' skin over that, which helps from a structural point of view. And really there's a great deal underneath the riveted aluminium that's on the outside – which Richard wanted *because* of the references to the golden era of aviation – that needed to be perfect. So really everything that happened inside was there to make sure the skin was in the right place and that's really where it came down to being a jigsaw puzzle. The 'jigsaw' had to fit together so the tailored cutting pattern of the aluminium would fit – dress – perfectly around the sculpture. So significantly it's *air* that we're encapsulating here, then dressing it in this beautiful airstream language of aviation history.

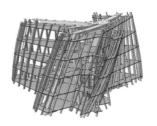

Maarten Kleinhout I suppose one of the real challenges beyond that is the fact that you cannot make your whole sculpture in one form and then chop it up into 23 pieces. You have to totally rely on the computer to ensure that when you make 23 individual pieces, not really putting them together, when they eventually *do* arrive on site and go together they *do* in fact create the form with very smooth jointing.

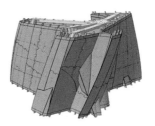

Tim Lucas Actually figuring out how to fit that structure through the shape of the aeroplane is one of the reasons there were 50 iterations of the shape. There was the process of understanding the shape, working out how much it might weigh and how that would affect the capacity of the structure inside to hold it between the columns. There was a very close circle among us [Price & Myers] as engineers and architects, CSi as the contractor and Richard. Really it was four of us as different stakeholders in the shape actually understanding how we could make all our requirements fit together in one overall sculpture balanced on those columns, keeping the centre of gravity flying down the middle.

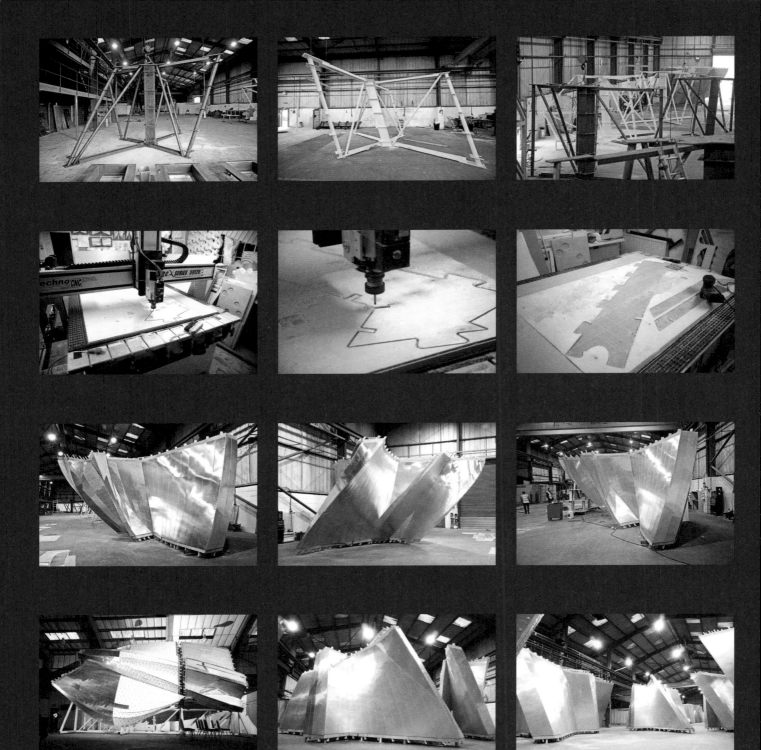

048

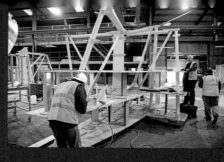
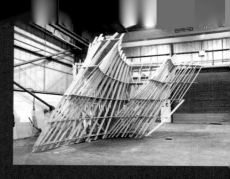
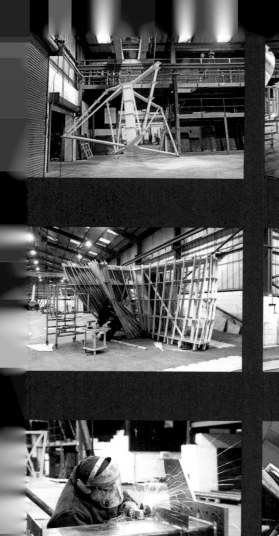
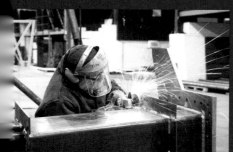

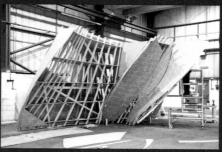
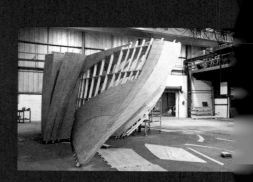
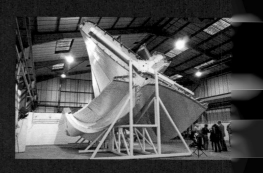
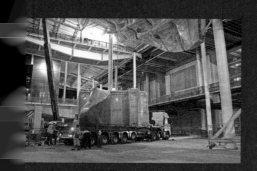
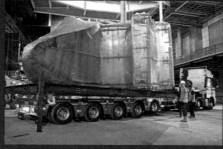

This spread: Photographic record of *Slipstream*
production at factory in Hull through to delivery
of the sculpture to Heathrow, 2011–2013

Opposite page:
Richard Wilson among
component parts at
CSi during a 2013 visit
to view the pieces pre-
transport to Heathrow

Richard Wilson Because, you know, if we could have got away with 10 [pieces] we'd have had a much easier structure to work with. But you have to design the sculpture in a component form that can be transported and that's where the 23 comes from. It wasn't, 'We'll make it in 23 bits.' We had to consider: how do you get it out of the factory? How do you get it on a lorry? How do you get it down the motorway? How do you get it onto the site? How do you get it in? So it was more, 'Right, what's it like to get out of the factory? How big's the lorry? What's it like to get it back into the space where it's going to live?'

Mark Davy There's a word that describes it: choreography. Because one of the striking things was just the sheer number of consultants and teams working inside that terminal all at the same time. I mean, that's the thing that hit me: just how *much* was going on while these guys were actually in there installing.

Andy Weber As a client with a programme of works, one thing you try to do is to manage the interfaces between the different projects in a way that means they stay as *separate* as possible. Before I took this role on the Landside team I was on the main terminal team. We had a lot of discussions with those developing the car park design about not hanging the walkways and bridges on the columns supporting the terminal roof because it was just too much of an interface – only *then* to decide to hang the world's longest sculpture on them instead! But it was absolutely the right decision. What's been said here about it probably undersells what a big deal it is to hang your artwork on someone else's columns. You're bringing in another party that realistically has no real incentive to be supportive other than they like the idea of it. It was difficult and there were further things that threw more complexity into that interface. Not least, how do you bring all that together safely so people aren't trying to do one thing above somebody else's head? Splitting it into 23 pieces sounds quite a lot for one sculpture but the pieces were still too big for us to bring in through the tunnel. So we couldn't bring them in the normal way people enter Heathrow and onto the construction site: they had to work with our airfield team to bring them in across the runway. A very supportive airfield team indeed! I mean, we're working in the world's busiest international airport, flights come and go to a timetable but unfortunately you still get late flights and you get early flights – you get all sorts. The choreography is immense to get each delivery to the airfield, get it checked for security, get it across the runway and get it back out the other side. I witnessed one or two of the deliveries and just the skill of the driver to reverse it into an incredibly tight space – weaving it through small gaps and other construction works, equipment and everything – was phenomenal.

Mark Davy Everything about it: the number of loads that came down; the six counties that it went across, each with their own rules about what can travel; and the outriders and vans and this thing edging out into the road. You could see it sticking out into the two lanes with a little van going along behind it. It's the *reality* of this that's so interesting. And the other thing I loved was the idea that there were these abseilers training up in Hull in order to do a particular job of fixing the sculpture to the columns.

Richard Wilson I was going to pick up on that. I was going to say that some of the most rewarding meetings were to do with the fact that these things were built as they should never be seen: they were built vertically. And they lived in the factory firstly, bar three of them. They came down the motorway vertically. And then we had a conversation that went on for

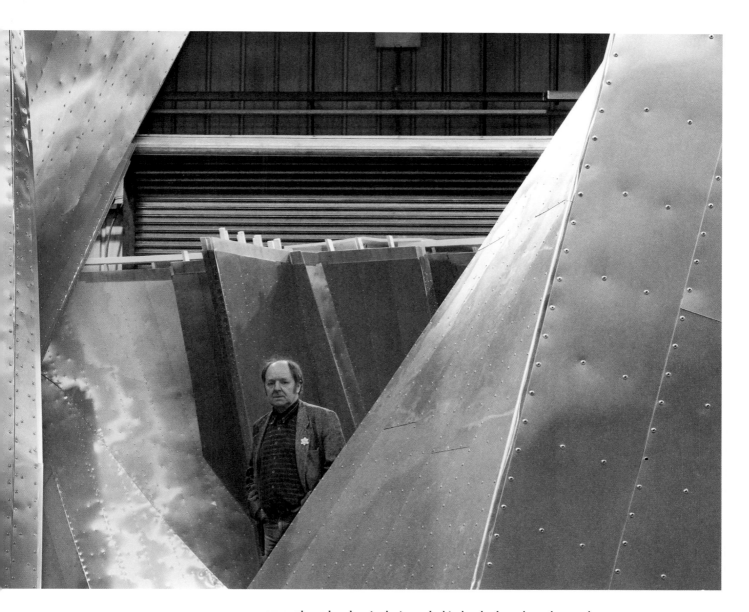

several weeks about what needed to be designed, engineered and then manufactured just to turn something 90 degrees. The time spent on the detail was phenomenal. There were beautiful moments, I thought, with conversations about that: looking at finite things that were all about common sense that you could probably date back to tipping up stones in ancient Egyptian times or pulling the stones to the pyramids.

Ralph Parker It's important to remember about this [sculpture] that no two parts are the same: there are over 100,000 pieces in it. In fact, that's a conservative estimate. And they're all different. Now obviously we can't draw every one of these components and even if we could it would be impossible for CSi to work through a stack of drawings the height of this room to build it in the time that we had: we had a very narrow time window to actually put it together. So we had to get the computer to do what computers do best, which is lots of repetitive operations, and we produced a series of pieces very much like an Airfix kit that come together and self-assemble. That was a real challenge and we had to think about things like material economy and how to reduce wastage.

Jean Wainwright I wanted to talk about the surface of the sculpture because how it looks and how it will be maintained is so important. So Richard, I know this exercised you greatly: how you would polish it and treat it so it would retain its reflective qualities.

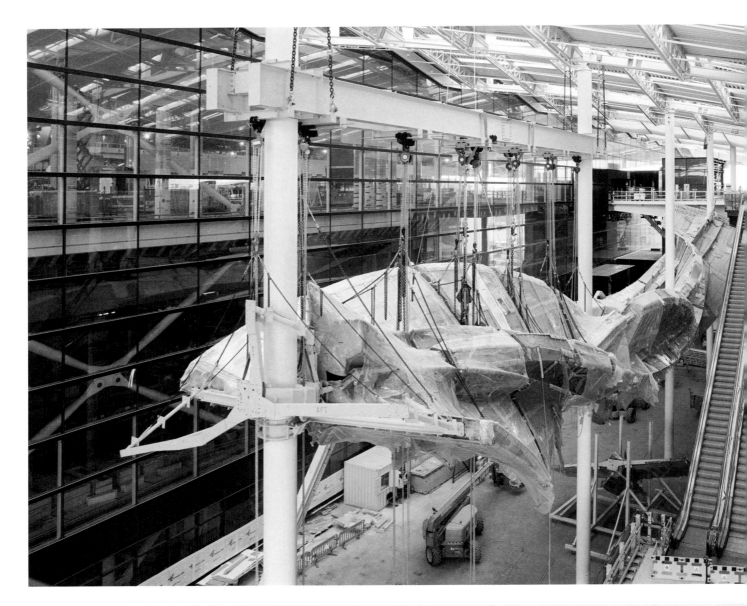

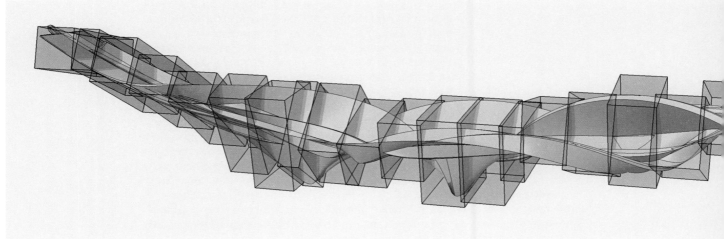

052

Richard Wilson We've used words like 'aerodynamic' and 'force velocity', all the things to do with flight, so it had to *hint* at that in some way. For a collective experience, we [the team] went to see the aeroplanes up on the top floor of the Science Museum. I also went to the Maritime Museum and looked at a couple of speedboats that had been pop riveted together in the '50s. We knew collectively that we wanted the surface to be aluminium, as it spoke 'aeroplane'. Personally I didn't want it highly buffed, which would have provided a very sensuous surface but would have pulled the surrounding architecture into the structure. I wanted it so that you had a polished surface with a sense of reflection. So CSi set up a series of tests where we had certain buffs done on aluminium sheets that were treated in different ways. I was looking at going down the road of waxing, which would have been a high-maintenance project. We finally went for powder coating, which changed it slightly from the picture I had in my mind. But it was the best surface that we could get to hold the reflective qualities that was also low maintenance, meaning that it doesn't need cleaning constantly and can probably fit into the same cleaning and maintenance scheme as the surrounding area. It also fits perfectly in terms of the form's relation to the structures surrounding it, and to the plane in which you will fly out of the airport. In terms of maintenance, I was [also] thrown a question which I really had difficulty providing an answer to: 'What do you do about birds wanting to nest?' You think, 'God, I wasn't prepared for that one!' Initially I ducked and dived with 'Well, use the same scheme as the airport uses,' but I didn't want spiking because that would affect the surface, and then suddenly you're changing the aesthetic and the reading of the piece. So I ran away and spent all night Googling…

Jean Wainwright For each of you, for all the team, what were the biggest learning experiences – or perhaps surprises – about this project?

Mark Davy I think my biggest thing was that if this was a Tate project inside the Turbine Hall, everything would be geared up for the art language, the terminology; everyone's roles are quite clear. If projects like *Slipstream* are going to be more common, which I think they are, what I'm beginning to realise is that once you move out of the museum and out of public-sector funding, then suddenly terms like 'curator' or 'producer' become hard to justify. Andy's organisation [Heathrow] is not a museum, it is not a gallery. It is a working environment with something very specific to do. And suddenly [*Slipstream*] is kind of *here*. So that's been, I think, the interesting problem – there's absolutely nothing like this.

Andy Weber It certainly knits together the terminal building and more sort of utilitarian – but may I say beautiful – car park, and somehow you don't really feel that you're going between the two. Part of that is because we are more used to seeing sculptures inside and we don't really feel that we're outside, which we are when we're looking at it – it's open either end.

Ralph Parker From my point of view, the nub of this project, the thing that makes it what it is, is its movement. Obviously the thing is that it's a frozen movement – architecturally frozen. You take all of that but everything is moving around it. The sculpture itself, although obviously it's static, appears to move, and it *will* appear to move in the changing light. People are moving around it, the airport is all about movement and what's most satisfying for me is how we managed to inject a record of that movement in the surface, in the skin of *Slipstream*, with our rivets. We had to generate about half a million of them during the course of the project and then figure out which ones sat on the outside. But what's really interesting about these rivets, if you look at them carefully, is that they are like the dots from a ticker tape in a physics laboratory, in the sense that where the motion that we've encapsulated is going faster they're further apart. Where it's slower, where parts of the plane or the plane itself are moving slower, they bunch together. And so what you really do have is a manifestation of a movement that is almost like sheet music – but in three dimensions – of the original acrobatic trajectory that we made.

053

Maarten Kleinhout What I learned in the early days was that to make some ideas work you want every piece, every individual, to feel like a part of it. You shouldn't really have a dominant factor or dominant ownership. Every individual – someone putting in a rivet, on the computer or engineering – *everyone* has got a little piece of *Slipstream*. And every one of them becomes a little bit of an author. They may well be an author within a boundary – a set of boundaries set by you, Richard – or a set of boundaries set by a process on site, or by installation technology. But the reality is that every individual has this little piece and takes real ownership and hold of that. From a management point of view, no matter what project you do, if you can generate ownership and pride it gives you a really creative and dynamic environment. It actually becomes very easy to manage in comparison to many other schemes, where you may fail to generate that ownership. We had a work team of 30 people on site, of which 20 of them worked uncompromising night shifts and very antisocial hours, and they were willing to do it because they wanted to be part of it. We had the factory open across weekends to make the delivery dates. And then Price & Myers put *hundreds* of hours into trying to produce this.

Andy Weber You've then got all the support people: you've got the Laing O'Rourke construction managers and their team and you've got the security guards who controlled the boundary as these pieces came across from airside into landside.

Jean Wainwright When Picasso painted *Guernica* (1937) there were numerous drawings and studies that you can actually see all contributed to the final composition. Richard, one thing I think is really important about the project is that you get a sense that *Slipstream* has kept very much to your initial ideas, your initial vision for it, with the obvious modifications we have talked about.

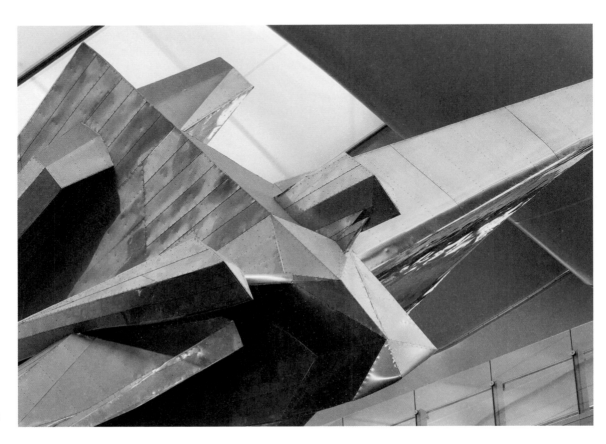

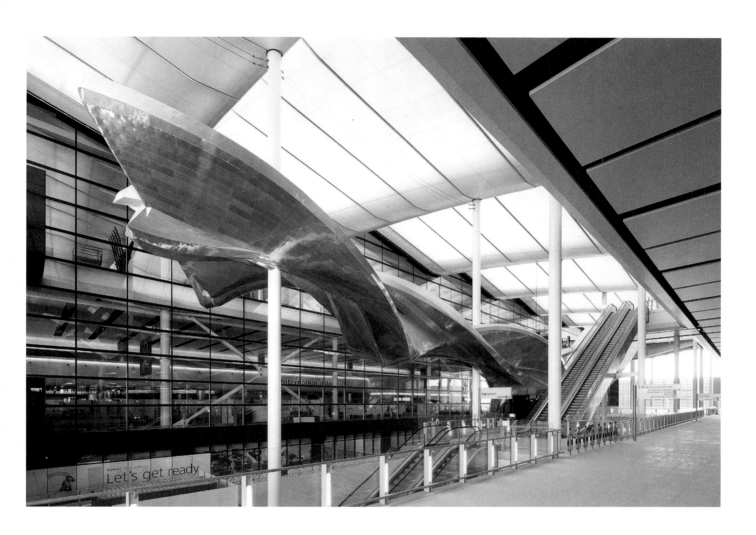

Richard Wilson What I did is lit the fuse. But I think bringing the team to the interview set the precedent, actually. To quote the shortest poem in the world, by Muhammad Ali: 'Me, We.' That was the issue right from the outset. It was like, 'Right, *we're* coming and *we're* going to tell you.' I think that's what has made it, fortunately. I can't do it on my own. I can only initiate the moment, the beginning.

Andy Weber To get to this point with the integrity of the piece intact – the fact that it actually is what it set out to be – obviously required us, as clients, to hold our nerve. But to hold our nerve we needed people behind us helping us to do it. Richard talked about turning and installing the sculptural pieces in situ and how they had to think it through at the design and planning stage in great detail – the devil is in the detail. So it was because all of that was done that Maarten turned up on site with 23 pieces of artwork and made it look so easy. Certainly CSi did a great deal of very complicated work and we are a very demanding client, especially when it comes to safety where we don't compromise at all. We cascade that through our contractors, so it can create quite a tense relationship sometimes. But not on this project – not with *Slipstream*.

Jean Wainwright Finally, Richard, I think people will have a very different experience of the sculpture depending on whether they are arriving or departing. How did you decide that *Slipstream* was going to fly from north to south rather than the other way round?

Richard Wilson It's actually facing the runway. It's going to the runway.

055

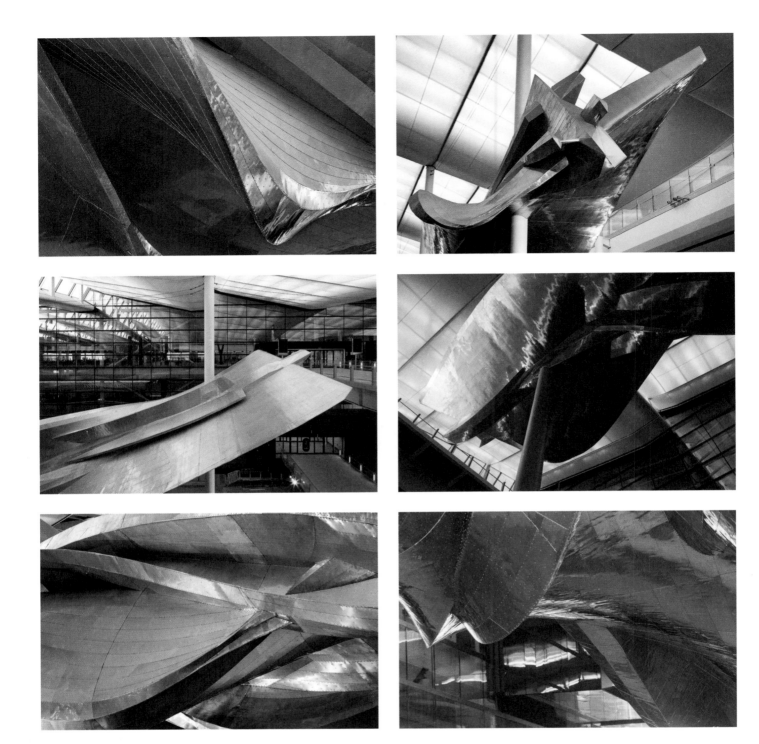

056

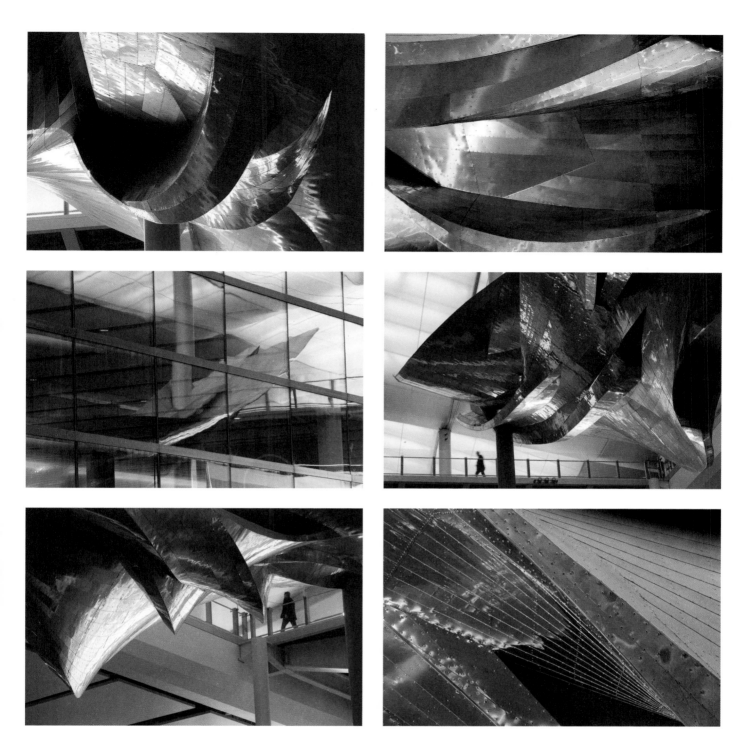

This spread: Photographic details
of the sculpture in Terminal 2

058

Part_No.04

All Roads Lead to Rome

By Jean Wainwright

Top: *20:50* (1987), Royal Scottish Academy, Glasgow, Saatchi Collection. Above: *20:50* (2010), Duke of York's Headquarters, London, Saatchi Collection

Richard Wilson has always been fascinated by the relationship between space and perception. He challenges the way we see our surroundings and negotiate our environment, pondering how things are constructed in order to find innovative ways to expand, reduce, crush, balance, build or suspend them. He has a passion for industrial materials and a desire to enhance and alter the locations that his installations or sculptures inhabit.

Wilson's surreal vision turns us into active viewers, confounding us with new perspectives on the familiar materials he uses. His captivation with surface and reflection creates elements of alchemy; by harnessing light, structures and materials, rearranging them or distorting them, his art dares us to think differently, filling us with childlike curiosity and wonder.

It is Wilson's creative methodology that provides the link between his previous works and *Slipstream*. At its heart lies his constant collection and distillation of ideas and artistic references, which he files away until they suddenly spring to the fore in what he calls his 'lightbulb moments'. These sudden creative flashes have always been an intrinsic part of his practice, throwing a project into sharp focus and immediately stimulating a flurry of activity, producing drawings and constructing models from whatever materials he has to hand.

As with *Slipstream*, the gestation of Wilson's signature sump-oil installation *20:50*, first exhibited in London's Matt's Gallery in 1987, began with an idea that emerged from a variety of different stimuli. Wilson was wondering how he might extend Matt's Gallery internally for an installation, using the principle of a Tardis. Submerged up to his neck in a swimming pool while on holiday, he had noted the 'powerful experience of looking at the flat plane of the reflective material'. He then remembered a container of used sump oil in his studio, which he had been using to anneal metal. It had accumulated a great deal of rubbish around the barrel but in the centre the blackness of the oil (which was up to the brim) was an intriguing reflection. The sight had reminded him of Barry Flanagan's 1969 film *A Hole in the Sea*, where Flanagan buried a hollow plastic cylinder in the sand during a rising tide then filmed the mysterious hole that appeared before the waves finally engulfed it. Wilson suddenly wondered what would happen if he flooded Matt's Gallery with oil. Like the early drawings and models for *Slipstream*, the excitement of the idea overtook him. Having no materials with him on holiday with which to construct a model, he eventually found an old shoebox which, with the aid of scissors and a glue stick, he fashioned into the first iteration of *20:50*. It was, he explained, 'quite a sculptural feat. I had to somehow convert the volume of the box into the live architectural space of Matt's Gallery, so I made a rather crude model… I liked the parallel of the rubbish found in the gutter and the oil that was discarded hazardous waste material. Sump oil is not something that's generally regarded as a sculptor's material. And yet here I was converting it from a rather slippery contaminant that you don't want to get on your suit or your dress into something beautiful.'

Opposite page, top: *20:50* (2003), County Hall, London, Saatchi Collection. Opposite page, right: *20:50* maquette made from an old shoebox, paint and glue in 1986

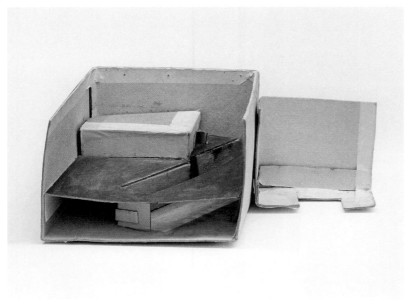

This page: *Turning the Place Over* (2008–2011), European Capital of Culture, Liverpool

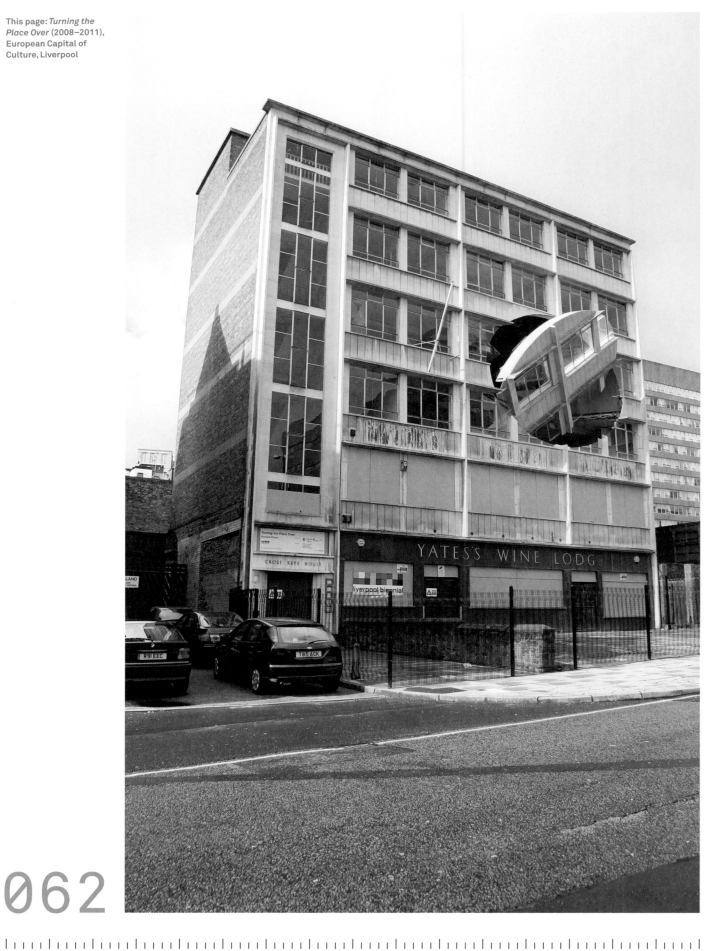

What was most important for Wilson was the 'invisible' reflective surface of the perfectly still oil, mirroring its environment. The smell of the oil that filled the specially made tank was a pungent reminder of something industrial and mechanical – and one that permeates the space each time it is remade for a different location. Wilson's adherence to 'truth to materials' is also evident in the 'uncompromising' riveted steel, which he used to form the narrow waist-high corridor leading to the oil. Its slight incline, tapered at the end, gives the reverse impression of wading into the sea.

By its very nature, *20:50* is dependent on its surroundings; it follows the topology of each room in which it is installed. Any feature at the edge of the space becomes embraced and doubled: the drainpipe in the corner of Matt's Gallery; the balustrade in the Royal Scottish Academy, Edinburgh (both installations in 1987); or, in the case of the Saatchi Gallery, the columns in the specially constructed room. All become subsumed by the oil's surface. Rather like *Slipstream*, which plays off the escalators and reflections in the windows in Terminal 2, *20:50* is affected by the visual interest in the room, which heightens its surrealistic effect.

As with *Slipstream*, with *20:50* Wilson was using materials that evoked 'language from the industrial world'. However, it is perhaps *Turning the Place Over* (2008), constructed for Liverpool's year as European Capital of Culture, that feeds most directly into *Slipstream* in terms of the creative methods used in its construction. The structural engineering for *Turning the Place Over* was designed with the assistance of Price & Myers, who credited the experience of rendering the work on computer from scanned models to resolve the design problems as helpful in developing methods to solve *Slipstream*'s complex engineering designs.

Turning The Place Over consisted of a 10-metre ovoid section cut from the Portland stone façade of a disused building in Liverpool city centre. Mounted onto a central spindle, the section rotated 360 degrees to reveal the inside of the structure before coming to rest flush against the building again, providing both a spectacle and a visual conundrum for those viewing it from below. The initial idea had emerged nine years earlier, again highlighting Wilson's long gestation periods. In 1999 he had embedded *Over Easy* into the building of Arc, a multi-artform venue in Stockton-on-Tees, but with this façade the work oscillated 300 degrees in just one plane. However, during the model-making stage a new idea emerged after Wilson had stuck a spindle onto a façade that had moved off line and hardened. Discovering this accident, Wilson spun it on his hand – which nine years later triggered the idea for *Turning the Place Over*.

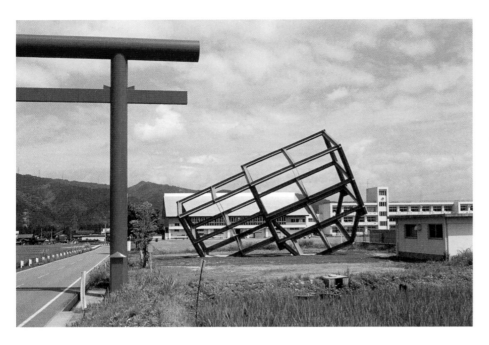

Above: *Set North for Japan (74°33' 2")* (2000), Nakasato village, Echigo-Tsumari Art Triennial, Niigata

So, which of Wilson's other works hint at the journey to the aesthetic of *Slipstream*? On the surface, both *Set North for Japan (74° 33' 2")* (2000) and *Butterfly* (2003) have a relationship to flight but like many of Wilson's works there is a complexity of ideas underpinning both their construction and final realisation.

Set North for Japan (74° 33' 2") initially caused problems for Wilson. Its proposed site in the grounds of Nakasato Junior School in the rural Japanese province of Niigata Prefecture, with its mountains and rice fields, was unfamiliar territory; very different from the urban environment and interiors that were usually the backdrop for Wilson's works. On his long-haul flight back to London the solution suddenly came to him. Looking out of the window he saw the sunrise highlighting the slight curvature of the Earth and thought, 'I'm an artist. I work with architecture. If I take my house in London around that curve I'm looking at now and put it in Japan, but at the same angle as England, that's the relationship. Two houses standing in different countries on opposite sides of the world at the same angle, which means that one is upside down.'

The line drawings he generated led to the replication of his brick house in London, reduced to a steel frame skeleton and sent to Japan. Upside down and rising at an oblique angle, it 'retained its precise relationship to its original site [in London], its

exact perpendicular and horizontal orientation to true north'.

We are reminded of Dorothy's house from *The Wizard of Oz*, tossed into the sky but in this case landing with exact mathematical precision. Yet there is also the dialogue between past and present, the old and the new, just as there is in *Slipstream*. The steel frame is a familiar sight in Japanese cities where the buildings, because of earthquakes, are often clad in heavy-duty steel. Travel, distance, time, relocation: Wilson's *Set North for Japan (74° 33' 2")* was once again in the territory of displacement, the familiar and the unfamiliar, welded together across different time zones.

Conceivably, *Butterfly* (2003) might be the most obvious choice for a work that has a conceptual relationship to *Slipstream*. Yet the similarities lie not in the fact that *Butterfly* began life as a scrapped Cessna light aircraft. Rather, they lie in the labour-intensive process of unravelling it under the gaze of gallery visitors, as well as the changes in shape of the aircraft itself as it was suspended in the Wapping Project Space in London.

The idea, Wilson explains, was a simple one: to unfurl the plane, which he had first crushed, and bring it back to a resemblance of what it had been before. But in the process another medium emerged in the form of a stop-frame film gathered from cameras in the ceiling space that recorded the physical unfurling process every five minutes. The film suggested a metamorphosis from a process to a product, from the 'compression of mass to a compression of time'.

Two-thirds of the way through the exhibition the sculpture, now resembling a buckled, crumpled plane, was severed from its central position to end up lying on the floor 'like a swatted gnat' in the back of the darkened gallery, obscured by a large screen. It had, as Wilson

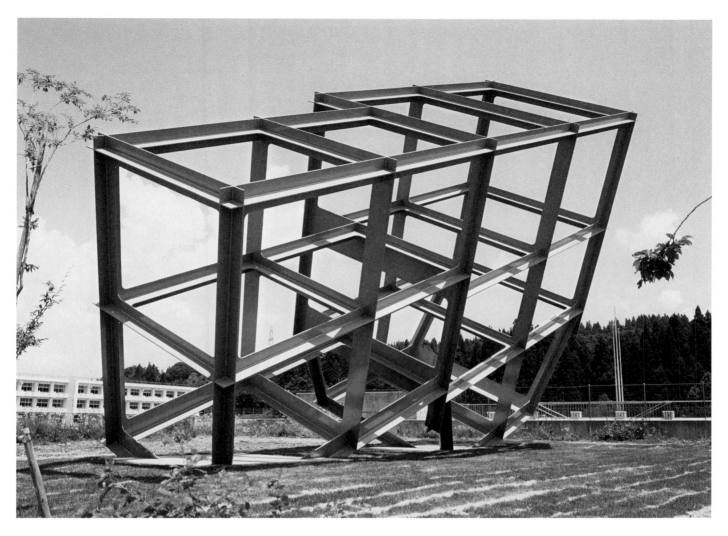

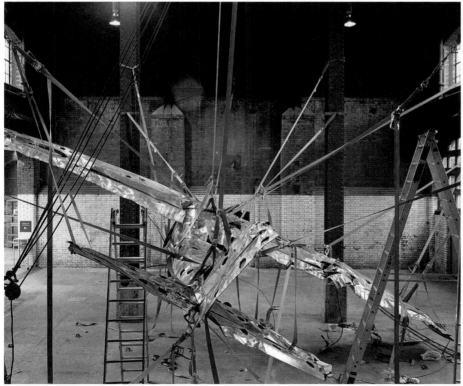

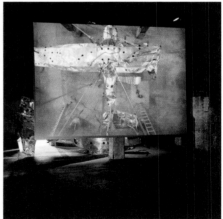

065

066

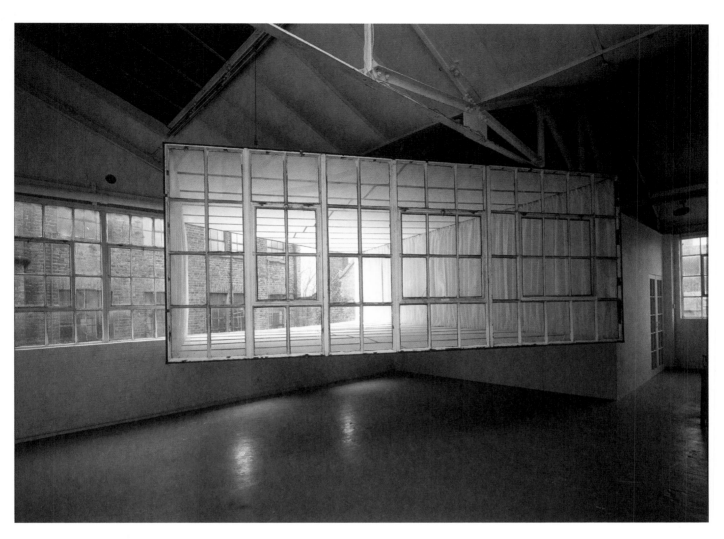

poetically explained, 'given birth to the film, a new life on screen'.

There are fascinating trajectories and patterns that emerge in Wilson's work. Just as *20: 50* had expanded the space in Matt's Gallery in 1987, so *She Came in Through the Bathroom Window* (1989) contracted it. In the latter case Wilson removed the gallery window from its housing and brought it into the gallery space, protruding into it in such a way that from certain angles the window appeared to be suspended in space. The world separated by the fragility of the window was now physically in the gallery. 'Before I'd flooded the space with oil – now I was flooding it with air, flooding it with the outside coming in,' he says.

Whether taking a dredger and reducing its length by 85 per cent, slicing from it a vertical section housing the habitable portion, as in *A Slice of Reality* (2000) (which still sits on six piles in the Thames with water lapping round it, open to the elements), or using

the idea of a plane cartwheeling in the air as in *Slipstream*, Wilson's canon is diverse, innovative and unexpected. He is taking things that we know and dislodging them, each work tantalisingly carrying within it the seeds of new works to come. As Wilson expresses it, in all his work he is 'tampering with the edge of where we think the certainty is in structures', and as *Slipstream* 'flies' through the space in Heathrow our imaginations soar with it.

Above: *She Came in Through the Bathroom Window* (1989), Matt's Gallery, London

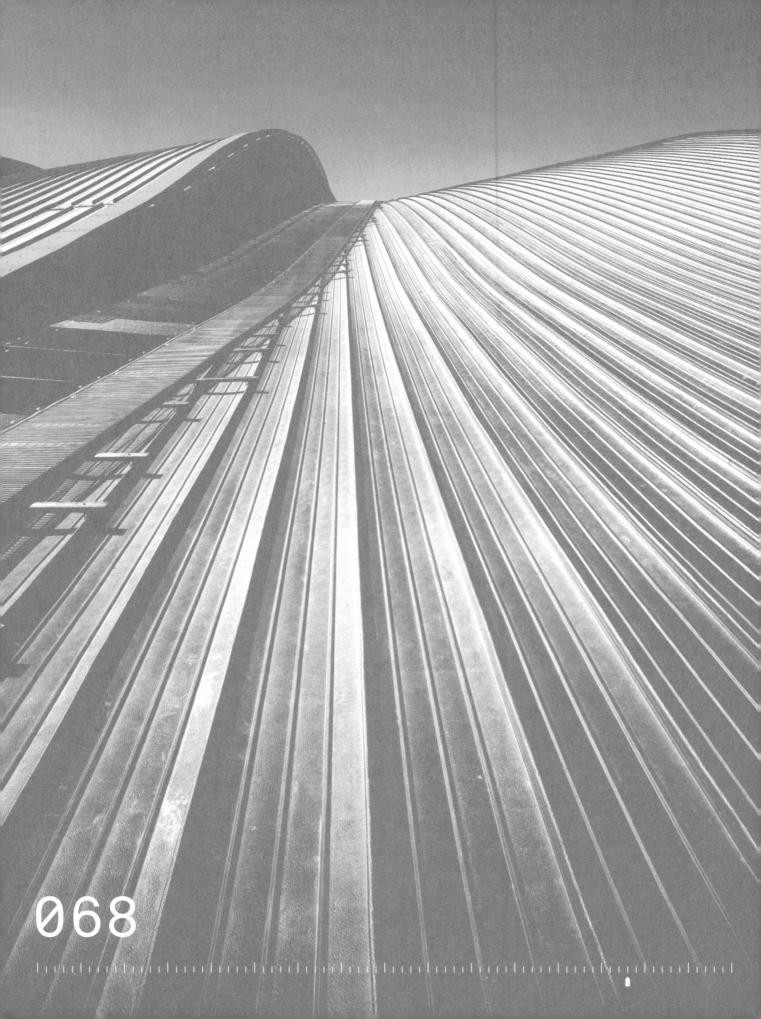

068

05

Part_No.05

The Heathrow Story

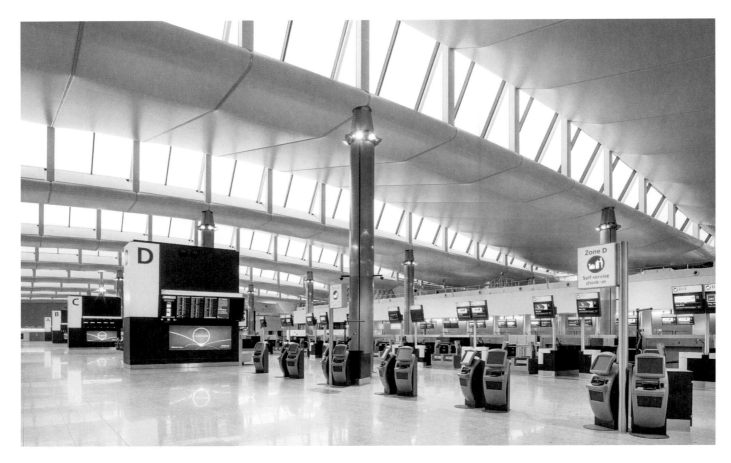

HEATHROW TERMINAL 2

Heathrow has spent over £11bn on the transformation of the airport, including a new Terminal 2 to replace the original Queen's Building and Terminal 2, which stood for more than half a century before closing in 2009. This iconic new terminal, built at the heart of the UK's nationally important international airport that welcomes over 72 million passengers a year, will reward flyers with an impressive new space, designed around the individual needs of the 21st-century passenger. The new Terminal 2 serves around 20 million passengers a year. It is home to 23 Star Alliance airlines, Aer Lingus and Germanwings, as well as Virgin Atlantic's Little Red domestic routes.

Luis Vidal + Architects, the concept and lead architects for Heathrow's new Terminal 2, collaborated with Pascall + Watson during the fit-out phase. Foster + Partners were the Heathrow Airport master planners and the East Terminal building concept architects during the initial project phase. The two main terminal buildings were constructed by HETCo (a joint venture between Ferrovial Agroman and Laing O'Rourke) and Balfour Beatty. The adjoining multistorey car park was constructed by Laing O'Rourke. The building cost £2.5bn of private investment, which includes the main Terminal 2 building, a new 522-metre satellite pier (T2B), Richard Wilson's *Slipstream* sculpture, a new 1,340-capacity car park and an energy centre and cooling station.

Heathrow has designed the new Terminal 2 with the aim to be as environmentally responsible as possible, with sustainability at the core of the programme. Ninety-five per cent of the buildings demolished to make way for the new terminal have been recycled. In addition, the new Terminal 2 will be 40 per cent more carbon-efficient than the old building and extremely energy efficient, with biomass (wood chip) boilers, photovoltaic panels and a main cooling plant carefully chosen for its low global-warming potential. Overall, Heathrow's target is to recycle or compost 70 per cent of airport waste by 2020.

This page: Heathrow, Terminal 2A, check-in hall, December 2013

Top to bottom: The new
Terminal 2A check-in
hall; the new Terminal 2B
Phase 2 departure gates;
Terminal 2A baggage-
reclaim hall, all 2013

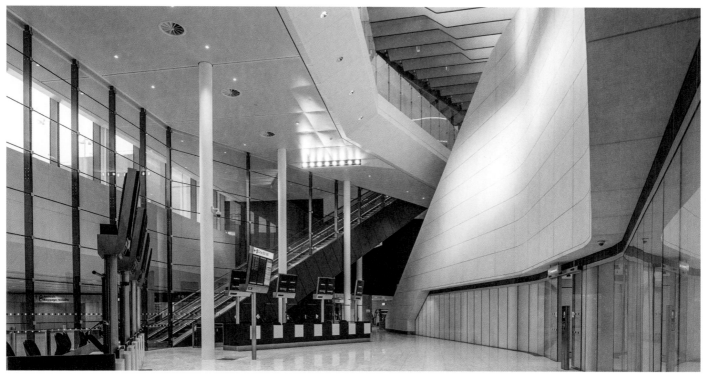

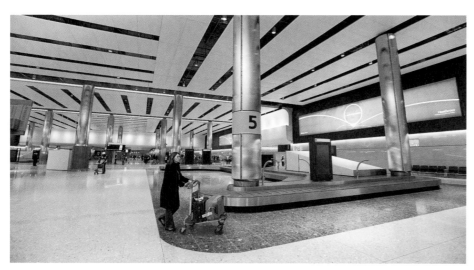

A MUSEUM WITHOUT WALLS

Top to bottom:
John Holland-Kaye,
Steven Livingstone
and Victoria Paul

On 4th March 2014, John Holland-Kaye, Heathrow development director, Steven Livingstone, Terminal 2 development director and Victoria Paul, Terminal 2 head of communications, gathered together in Luis Vidal's brand new Terminal 2 building with Mark Davy, director of Futurecity and curator of the *Slipstream* project. With the magnificent flowing space and *Slipstream* as a backdrop, the conversation ranged from whether an airport terminal could be a cultural destination to the importance of *Slipstream* as a sculpture, and how the synergy of Richard Wilson's art with Luis Vidal's architecture would enhance the passenger experience. As Mark Davy commented, Heathrow has been an exceptional client and *Slipstream* marks a new way of commissioning contemporary art as part of a placemaking strategy that will result in Terminal 2 becoming a new destination in London to see art – a museum without walls.

Mark Davy Can we talk about how you envisage the passenger experience to be when passing through the transformed Terminal 2?

John Holland-Kaye Imagine coming to Europe, perhaps for the first time. You're coming through Heathrow as the gateway to the UK, you've had this fantastic experience from the plane to going through the architect's beautiful light terminal and then suddenly there's *Slipstream*. You weren't expecting it, you don't know what it is but it says something about the UK: that not only can we design great buildings, not only can we be really efficient but we also care about art. That will just give such a fantastic first impression of the UK for the millions of overseas visitors to the UK each year.

Victoria Paul *Slipstream* will welcome you to the UK but is it also a great parting gift. I don't think any other terminal in the world has anything similar – it's unique. Every year, Heathrow Airport welcomes over 72 million passengers and Terminal 2 is the next part of the transformation of the passenger experience. Everyone will enter and leave the terminal through the central courtyard area, where the journey really begins – or continues.

Mark Davy What did you think when you first saw Richard Wilson's proposal?

John Holland-Kaye When we looked at all of the proposals that came forward with the international competition, *Slipstream* instantly grabbed us. It said, 'This is about Heathrow. This is about aviation. This is about the whole history of the last 60 or 70 years while Heathrow has been here.' The Terminal 2 building is designed to last for 50 years so a billion people will see Richard's work in the course of its life. That's just an extraordinary thing: to touch so many people's lives all over the world.

Mark Davy Now that the terminal is complete, how do you think Richard's sculpture works in the context of the overall design?

Victoria Paul You've got the fluid motion of the sculpture and the synergy with Luis Vidal's architecture. It all works together and from start to finish you feel that it's all part of one journey. You might not necessarily think of Heathrow Airport from a cultural point of view but art, architecture, engineering and aviation, all coming together and having exposure to lots of different audiences, actually gives us a fantastic opportunity to really show what our brand represents: the best possible passenger experience whether departing, arriving or connecting.

John Holland-Kaye It's made us realise that there's a strong artistic vein running through Heathrow. If you look at the work that Richard Rogers and Norman Foster have done here, and now Luis Vidal, there are some stunning designs. Heathrow is a showcase for that internationally: it's something that is part of their repertoire. We hadn't really thought of it in those terms, that they are artists in their own right, but they've created some fantastic facilities and beautiful

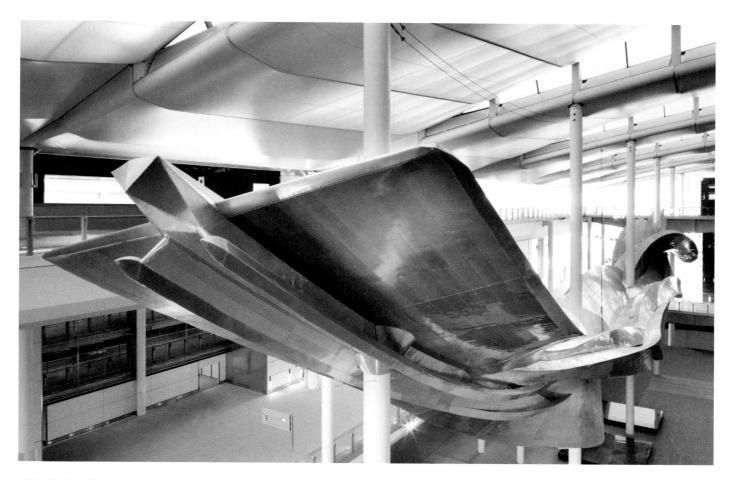

Above: *Slipstream* in place. Left: Terminal 2A's roof architecture, which the sculpture perfectly complements

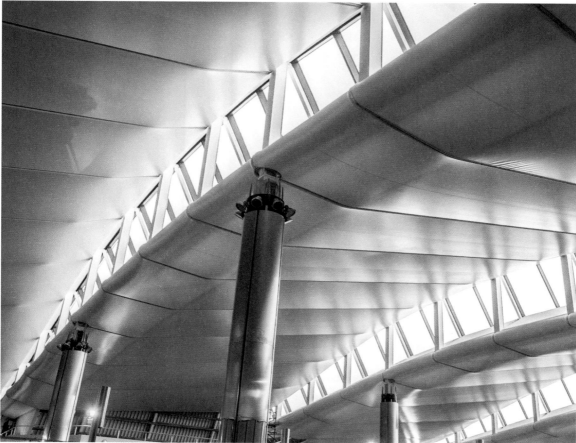

073

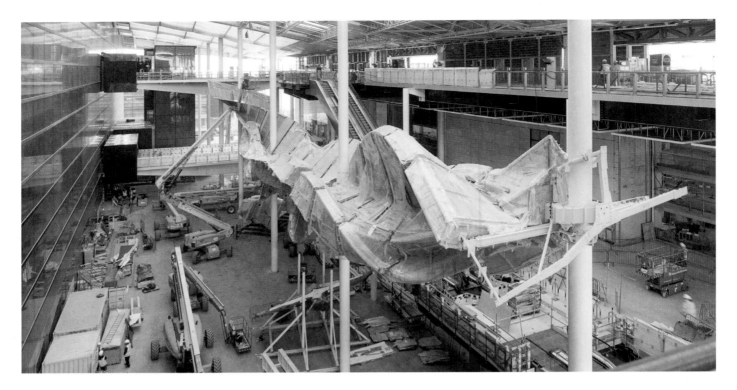

Top: The installation process, 2014.
Above: A view of the forecourt area as Terminal 2A is constructed, 2012

terminals. Richard's work fits into that. We're really pleased that we've been able to integrate architecture with some inspiring and monumental art as well. These people will always be linked to the work that they've done here so we also benefit from the fantastic reputation *they* have around the world. One of the things that attracted us about Richard was his engagement. This wasn't just another piece of art for Richard Wilson: this was part of his canon. He wanted to be known for *Slipstream* and was going to put his own personal heart and soul into it, and that gave us comfort that we would have a success on our hands. What I wanted was the most *beautiful* piece of sculpture in Europe – and I think that's what we have here with *Slipstream*.

Mark Davy How have you managed to keep a British emphasis in the design and operation of the new terminal?
Steven Livingstone We want people to know they are in *London*. We're proud of being here. Our city had a tremendous time through 2012 with the Olympics and that reinjected a lot of our goodwill; feeling good about being English and being British. We've carried that forward, so you want to know that when you come here, 'I'm in London and the UK.' The great thing for me is that first of all you're going to look at *Slipstream* and you're going to go 'Wow!' It's so different, it's in a great area and it's the front door

to this tremendous facility we're mightily proud of. I hope it inspires people to be inquisitive, whether it's about the sculptor, the arts or Heathrow.
John Holland-Kaye We wanted people to get a sense that when you're in Terminal 2 that you can be nowhere other than in the UK, nowhere other than in London. Nationally, Heathrow is the UK's most important international airport. It connects UK businesses and people with the world and it made us think about how to get that sense of Britishness here into the terminal. It led us to talk with other British institutions: John Lewis opening its first airport store; Heston Blumenthal, with his first airport restaurant; and others such as Mulberry, Burberry and Fuller's, giving them a showcase for what they do. This will help to promote their brands to the world. What we didn't want was for people to look at Terminal 2 and think it was a bit like Terminal 5. We wanted it to have its own identity as well as having this real sense of Britishness here in Heathrow and the terminal. That made us think more widely about how we could use that space.

Mark Davy What has it been like following the development and construction of *Slipstream*?
Steven Livingstone It's been brilliant to watch the sculpture grow in front of our eyes since it started coming down

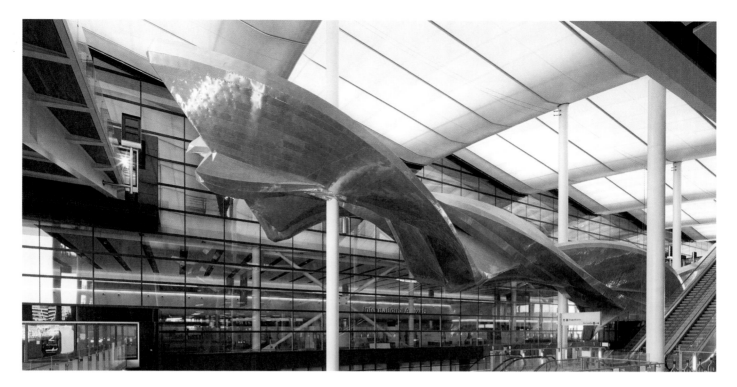

from Hull. We have a lot of pride in *Slipstream*. So it's actually started its life in the feeling of pride that we have in this great terminal. I think that's been really tremendous and I've actually loved being part of installing *Slipstream* here. It's had an effect on us. Now. looking at it, it's magnificent. It was a challenge but a challenge well worth taking on. That's the great thing about *Slipstream*: it will always be associated with Heathrow Terminal 2. This is the only airport I know which has such a monumental piece of art.

John Holland-Kaye When *Slipstream* was being installed it was a little bit like having the heart put into the building that would bring it all to life. That's very much what you feel now: you walk past it and it has a sense of motion, it's very vital. You can imagine people seeing it and not knowing what it is, trying to figure it: 'What am I looking at? Why have they put this here?'

Mark Davy How have you managed to oversee such a large arts project? Steven Livingstone We've done it by trusting people who are experts in the field. We wouldn't know what to do with art as substantial as that so we could have become very insular and said, 'Oh, it's just a bit of art.' But we didn't: we became very proud of it very early on. We wanted to tell people about it, we wanted to spread the word – and it

really comes back to how proud we are about having a piece of art like that in our terminal and Heathrow that we're proud of as an entity. We've been *able* to be different.

Mark Davy Terminal 2 is an important part of Heathrow's history, isn't it? Victoria Paul Yes. I think a big part of the difference between Terminal 5 and Terminal 2 is that there's a lot of history and passion from people who used to work here and travel through Terminal 2. It's the Queen's Terminal – it used to be the Queen's Building – and that nostalgia is really important. In the previous Queen's Building the roof garden and the roof terrace really were a feature and I think that in the new building *Slipstream's* going to be a feature again.

Mark Davy We know the Queen saw a model of *Slipstream* last year at the Royal Academy of Arts. What would you like her reaction to the finished sculpture to be? John Holland-Kaye I'd like to think that the Queen would see this as being part of her legacy. She's been associated with Heathrow for all of her reign. She landed here when she first came back from Africa and she's been particularly associated with Terminal 2. I'd like to see *Slipstream* being, for her, part of a new Elizabethan age for the 21st century.

Top: *Slipstream* in all its glory. Above: Top-level entrance from vehicle drop-off point

Richard Wilson

Born in 1953, Richard Wilson is internationally celebrated for his interventions in architectural space, which draw heavily from the worlds of engineering and construction for their inspiration.

Wilson has exhibited widely both nationally and internationally for over 35 years and has made major museum exhibitions and public works across the world, including Japan, China, the US, Brazil, Mexico, Russia, Australia, northern Iraq and throughout Europe. He has represented Britain in the Sydney, São Paulo and Venice Aperto Biennials and the Yokohama and Aichi Triennials. He was nominated for the Turner Prize in 1988 and 1989 and was awarded the prestigious DAAD residency in Berlin in 1992. He was one of a small number of artists invited to create a major public work, *Slice of Reality*, for the Millennium Dome site in 2000 and was the only British artist invited to participate in the Echigo-Tsumari Art Triennial 2000 in Japan.

Wilson's projects have attracted critical and public acclaim. His seminal installation *20:50*, a sea of reflective sump oil, is the only permanent installation at the Saatchi Gallery and has been continuously shown in each of the gallery's venues since 1991. It is currently on display in Gallery 13 of the Duke of York's Headquarters in Chelsea and was described as 'one of the masterpieces of the modern age' by art critic Andrew Graham Dixon in BBC television series *The History of British Art*.

Wilson was appointed visiting research professor at the University of East London in 2004, elected as a member of the Royal Academy in 2006 and in 2008 was awarded an honorary doctorate at the University of Middlesex. He is currently serving a four-year honorary professorship of sculpture at the Royal Academy Schools. *Richard Wilson* by Simon Morrissey was launched in October 2005 as part of the Tate Modern Artists Book Series (Tate Publishing). Wilson's commissioned contribution to Liverpool's European Capital of Culture 2008 was *Turning the Place Over*, which comprised a vast ovoid section of a building's façade rotated three dimensionally on a spindle. It was launched in June 2007 and operated until 2011.

His exhibition at the De La Warr Pavilion, Bexhill in 2012, entitled '*Hang on a Minute Lads... I've Got a Great Idea*', had a hydraulically teetering coach positioned at the edge of the building's roof – a replica of the vehicle featured in *The Italian Job* (1969). This cinematic moment acted as a flag-waving work for the nation as part of the Cultural Olympiad 2012 Festival.

Richard Wilson is represented by Michelle D'Souza Fine Art

richardwilsonsculptor.com

Price & Myers
Established in London in 1978 as a firm of consulting structural engineers with the aim of working with good, imaginative architects, clients and artists to make excellent buildings and sculptures. In its first 33 years it has completed over 20,000 jobs and won over 350 awards. Price & Myers has offices in London, Nottingham and Oxford and employs around 120 people. The company collaborated with Richard Wilson in 2008 on his piece *Turning the Place Over*.
pricemyers.com

Futurecity
A culture and placemaking consultancy working in an urban context. We create cultural strategies, broker cultural partnerships and deliver multidisciplinary art projects from inception to completion. Futurecity works with artists interested in a collaborative relationship with other disciplines, often as part of a wider placemaking strategy. We champion artists who want to change the way art is presented in the public realm and in galleries without walls. Our ambition is to attract new audiences, develop new funding streams and find ever more challenging cultural projects.
futurecity.co.uk

Commercial Systems International Ltd
A Hull-based firm that specialises in the design, fabrication and installation of bespoke structures and total façades. Formed in 1986, CSI is a skilled, professional team dedicated to the delivery and design of engineered and architectural products. CSI collaborated with Richard Wilson in 1998 on his piece *Over Easy*.
commercialsystemsinternational.com

Dr Jean Wainwright
An art historian, critic and curator. Wainwright has published extensively in the contemporary-arts field as well as appearing on television and radio programmes including BBC Radio 4's *Today* programme, plus Channel Four and BBC documentaries. She has won awards for her TV work. Over 150 of her interviews for arts magazine *Audio Arts* are in London's Tate Gallery collection. She is Head of Cultural Studies at the University for the Creative Arts (UCA).

Richard Wilson RA would first and foremost like to thank the client Heathrow, curators Futurecity, engineers Price & Myers, fabricators Commercial Systems International, HETco (Laing O'Rourke-Ferrovial Agroman joint venture), Sutton PR and the large number of individuals, organisations and businesses that, with their dedication, intelligence and commitment over the past four years, have helped make *Slipstream* a reality.

Jennifer Barnes
Steve Bird
Paul Bonhomme
Jim Boys
Pete Brady
Ian Chapman
Tony Cheshire
Tim Coffey
Mark Davy
Robert Davy
Erika Elms
Steve Fee
Jonathan Fitzgerald
Marcus Foley
Mike Forster
Jim Gover
Katie Green
Mike Green
Stuart Green
Iwona Hall
Stuart Hall
Clare Harbord
John Holland-Kaye
Jason Hrusa
Dale Hughes
Jonathan Kleinhout
Maarten Kleinhout
Karl Laurenson
Colin Ledwith
Gavin Little
Steve Livingstone
Tim Lucas
Jonatas Moutinho
Liz Neighbor
Alan Newlove
Robert Nilsson
Paul Palmer
Ralph Parker
Victoria Paul
James Rixon
Mike Robinson
Mark Rock

Karen Rogers
Catherine Shuttleworth
Heat Sirrs
Danny Stevens
Carole Stokes
Martin Summersgill
Nadine Thompson
Mick Thornton
Jeremy Timings
Paul Toplis
Chris Turner
Lucy Tyler
Joel Underwood
Emmanuel Verkinderen
Dr Jean Wainwright
Nick Watson
Andy Weber
Joanne White
Phil Wilbraham
Les Wilson
Richard Wilson
Will York
Eric Zivko

Reproduction Credits

Pg 20: Boccioni, Umberto (1882-1916), *Unique Forms of Continuity in Space* (1913). Milan, Civico Museo d'Arte Contemporanea.

Pg 22: Muybridge, Eadweard J. (1830-1904), *Man and horse jumping a fence* (1887), Plate 640 from *Animal Locomotion*, London, Stapleton Historical Collection.

Pg 23: Duchamp, Marcel (1887-1968), *Nude Descending a Staircase (No. 2)* (1912). Philadelphia, Philadelphia Museum of Art. Oil on canvas, 57 7/8 x 35 1/8' (147 x 89.2 cm). The Louise and Walter Arensberg Collection, 1950.

Photography Credits

Pg 6: © Richard Wilson
Pg 9: © David Levene
Pg 10: © David Levene
Pg 12–13: © David Levene
Pg 15: © David Levene
Pg 16: © Miyako Narita
Pg 19: © Natural History Museum, London
Pg 20: © Richard Wilson; © Joevare; © 2014 Photo Scala, Florence
Pg 22: © 2014 Photo Scala Florence/ Heritage Images
Pg 23: © 2014 Photo The Philadelphia Museum of Art/Art Resource/Scala, Florence; © Joe Clark
Pg 24: © Anthony Charlton/Courtesy of LHR Airports Limited
Pg 25: © Price & Myers
Pg 26: © Maarten Kleinhout
Pg 27: © Miyako Narita
Pg 28: © David Levene
Pg 29: © Price & Myers
Pg 30: © Ralph Parker, Price & Myers
Pg 33: © Stuart Leech
Pg 34: © Richard Wilson
Pg 36–37: © Richard Wilson
Pg 38: © Joe Clark
Pg 39: © Joe Clark
Pg 41: © Ralph Parker, Price & Myers
Pg 42–43: © Colin Ledwith
Pg 44: © Joe Clark
Pg 45: © Joe Clark
Pg 46: © Joe Clark; © Price & Myers
Pg 47: © Price & Myers
Pg 48: © Ralph Parker; © Tim Lucas; © Maarten Kleinhout; © Miyako Narita
Pg 49: © Ralph Parker; © Tim Lucas; © Maarten Kleinhout; © Miyako Narita
Pg 51: © Miyako Narita
Pg 52: © Steve Bates/Courtesy of LHR Airports Limited; © Price & Myers
Pg 54: © David Levene
Pg 55: © David Levene
Pg 56: © David Levene
Pg 57: © David Levene
Pg 58: © Anthony Wilson
Pg 60: © Antonia Reeve; © Richard Wilson
Pg 61: © Stephen White; © Richard Wilson
Pg 62: © Anthony Wilson
Pg 63: © Anthony Wilson
Pg 64: © Shigeo Anzai
Pg 65: © Richard Wilson; © Peter Marlow; © Stephen Morgan
Pg 66: © Richard Wilson
Pg 67: © Edward Woodman
Pg 68: © Steve Bates/Courtesy of LHR Airports Limited
Pg 70: © Steve Bates/Courtesy of LHR Airports Limited
Pg 71: © Nick Wood/Courtesy of LHR Airports Limited
Pg 72: © This is Tommy Ltd
Pg 73: © David Levene; © Nick Wood/ Courtesy of LHR Airports Limited
Pg 74: © Steve Bates/Courtesy of LHR Airports Limited
Pg 75: © David Levene; © Steve Bates/ Courtesy of LHR Airports Limited
Inside covers: © David Levene

'*Slipstream* makes present the special kinetic moment of travel. In the airport we flow through time, leaving a special drawing of our movements from departure to arrival, arrival to departure.'

Richard Wilson, 2014

080